L.S. Lowry
Masterpieces of Art

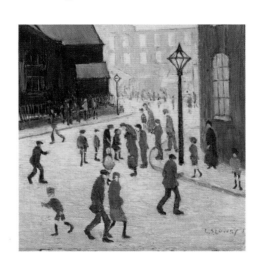

Publisher's Note:
Plates may not be removed from the book for the purposes of any other
usage, including framing and wall decor.

Publisher and Creative Director: Nick Wells
Project Editor and Picture Research: Laura Bulbeck
Art Director: Mike Spender
Layout Design: Jane Ashley
Digital Design and Production: Chris Herbert
Copy Editor: Ramona Lamport
Indexer: Helen Snaith

Special thanks to Tony Smith and Claire Stewart from The Lowry,
and David Roe and the rest of the team at Rosenstiel's

FLAME TREE PUBLISHING
6 Melbray Mews
Fulham, London SW6 3NS
United Kingdom

www.flametreepublishing.com

First published 2015

15 17 19 18 16
1 3 5 7 9 10 8 6 4 2

ISBN 978-1-78361-357-1

Printed in China

L.S. Lowry
Masterpieces of Art

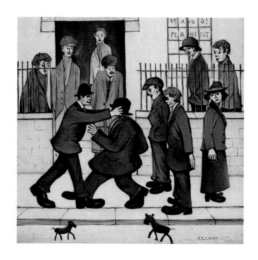

Susan Grange

FLAME TREE
PUBLISHING

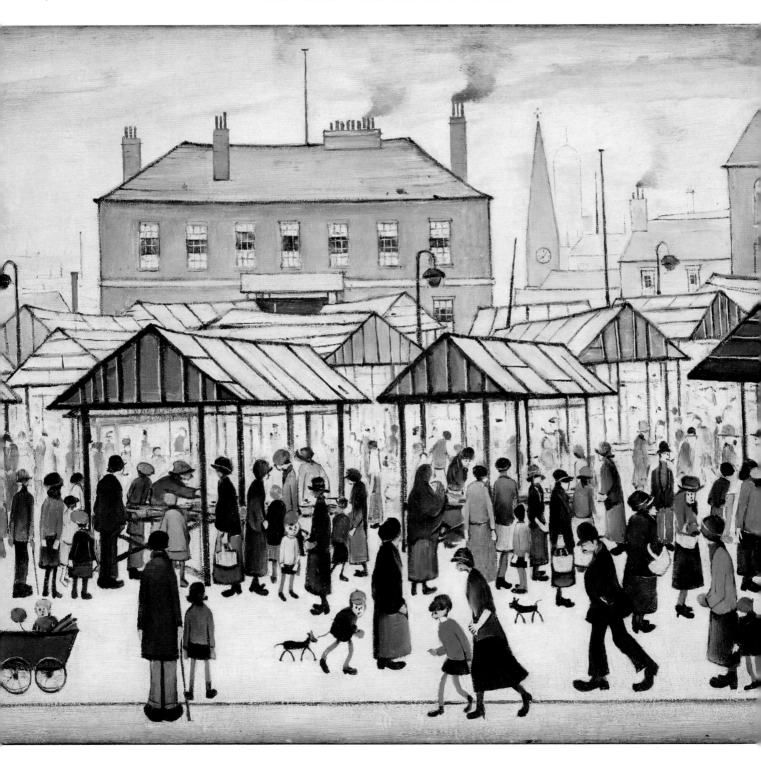

Contents

L.S. Lowry: Visions of the Industrial Landscape

Laurence Stephen Lowry (1887–1976) decided to make the industrial scene his own. In his many depictions of north-west England he showed how industry had affected the landscape and how the inhabitants of the urban areas lived out their daily lives. Marches, evictions, accidents, illness, relaxation at the park or the fair, going to work, coming out of school, going to the football match were all subjects for Lowry's brush or pencil. These works were created in his own unique style, poetic yet not sentimental, compelling, even at times disturbing, but never judgemental. Greatly loved by the population at large, Lowry's work still polarizes the opinion of art critics but he is viewed as a serious artist by art historians. His creative portrayal of individual figures and his numerous studies of the sea and boats all add to the wider appeal of this twentieth-century giant of the British art world.

Early Days

Painting did not seem to run in the Lowry family – however creativity and artistic expression did. Lowry's mother, Elizabeth (d. 1939), was an exceptional pianist. Whether if circumstances had been more favourable she would have been able to carve out a career as a concert pianist is not known, but it seems that she would have dearly loved to do so. To be an exceptional pianist requires much talent, hours of practice and an ability to communicate expression and reach out to others; artistic characteristics that Laurence – or Laurie as he was known in the family – clearly inherited, only for them to manifest themselves in a different sphere. Laurie proved to have little talent for music and it seems to have been left to the wider family of aunts, uncles and cousins to notice that he was frequently drawing. His father would take him occasionally to visit Manchester City Art Gallery, but it was on holiday with the extended family group that his sketches of boats and sea views on various scraps of paper were noted and remembered by other family members.

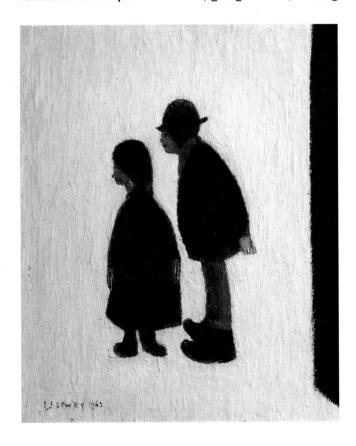

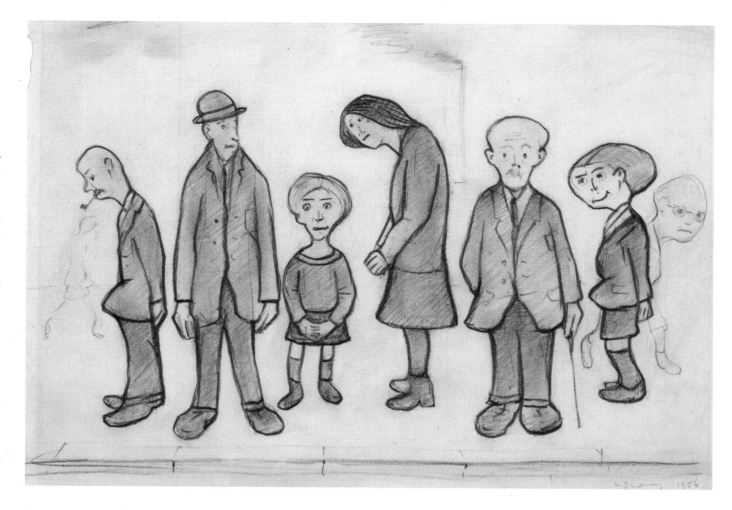

Lowry seems to have felt himself to be a misfit, something of an outsider from a very early age. Clumsy and ungainly, others considered him to be shy and a little odd. His mother insisted he went to an expensive private school that he hated, partly due to the merciless teasing from the other children and the sarcasm of the teachers. He did, however, receive a Certificate for Special Diligence in dictation, geography and writing. In later life he would boast that this was the only academic certificate he had ever been awarded.

Family Life

Lowry would often refer to his unhappy childhood but the wider family circle was strong and gatherings were frequent and happy occasions, with family members recalling that Lowry seemed to have enjoyed them.

The atmosphere at home with his parents, however, appears to have been different. His father, Robert (d. 1932), was a diligent clerk who lived a regular, disciplined life. He was an experienced lay preacher and president of the Sunday School at St Clement's Church, Longsight. People who knew him referred to him in positive terms. Elizabeth was clearly a talented, able woman but although she taught the piano she did not seem to have found satisfaction in this. Her desire for a higher social standing, coupled with her regret for the performing career that never was, affected every aspect of the household. People would refer to her poor health and suffering, and the demands she put on her husband and son. Hearing her complaints about how her health had suffered since the birth of her son and how having a child had hindered her career, it is likely that Laurie took this guilt upon himself.

Elizabeth increasingly adopted the role of invalid, demanding a maid to attend her and getting others to minister to her every need; none more so than her husband and son.

Upward Mobility

Elizabeth's aspirations to greater social standing were fulfilled for a time when the family lived on the edge of Manchester's Victoria Park. This was a private residential area with some grand houses and home to the great and good of Manchester society. Despite his parents' lack of interest – his mother in particular did not like or rate his work – Laurie had clearly developed a desire to draw, which filled his time and absorbed him in his lonely hours at home. This resulted, surprisingly, in Laurie making his own efforts to win a full-time place at art school; one of the few times, it seems, that he asserted his own will over that of his parents. Unsuccessful in gaining a place, there was nothing for it but to go out to work. In 1904 Lowry gained employment as a clerk at a chartered accountants' firm in Manchester and so began his working life, which continued until he took formal retirement at the age of 65. However, his desires for an artistic education were not to be suppressed and in 1905 he enrolled in drawing and painting classes at the Municipal College of Art in Manchester.

Family Crisis

Urged on by his parents to better himself, in 1908 Lowry found a new post as a claims clerk at the General Accident Fire and Life Assurance Corporation. However, the financial situation at home was deteriorating. Victoria Park was too expensive and Robert Lowry decided that his family must move. In May 1909 the family moved to Pendlebury, an area of mills and chimneys, soot and overcast skies, grime and noise. The new family home was spacious and initially bright but soon became gloomy and depressing, reflecting Elizabeth's mood. The move was a humiliation for her and she detested everything about the house and its surroundings. She went out increasingly rarely, played the piano less frequently and stayed in bed longer; that she dominated the household was clear. However, both husband and son seem to have attended to Elizabeth's needs not simply out of duty but with care and concern, so it may be that

Elizabeth had warmer qualities which inspired her family's genuine compassion and support.

The Pall Mall Property Company

In 1910 Lowry was made redundant from his job at General Accident but quickly found a new job at the Pall Mall Property Company Ltd, the job that he would keep until his retirement. This job entailed collecting rents from tenants in many of the inner-city areas and so furnished Lowry not only with the backdrop but also with the subject matter for many of his works. He would be frequently seen sketching on scraps of paper and the backs of envelopes as he went on his rounds. In 1943 he said: 'If I was asked my chief recreation, I ought to say, walking about the streets of any poor quarter of any place I may

happen to be in.' Lowry was, in fact, describing his job: a job where as he walked he not only observed architecture and settings but also gathered images of people and events that could eventually be used in his works. That many of the same tenants he saw on his rounds called into the Pall Mall offices also provided him with opportunity for further observation. And so the die was cast. The industrial landscape of Pendlebury was Lowry's new home backdrop and the inner-city streets of his rent-collecting round were his daytime environment; the stage-set for the development of his unique contribution to art was all in place.

Training

In later years Lowry would get very irritated by people who said that he was untrained or simply a 'primitive' artist or even 'a Sunday painter'. In fact, Lowry was involved in art education as a student from 1905 to 1928 when he eventually decided to stop going to classes, a considerable time period of serious study and training. With his small income from his job, the young Lowry first of all took some private lessons with two local artists. By 1905 he had begun studies in the evenings at the College of Art where he had to draw from the antique, working from plaster-cast statues, and where he also worked on figure drawing in the life class. In later life he stressed the importance for artists to have such a foundation for their work, stating: 'I still believe that long years of drawing the figure is the only thing that matters.' His *Reclining Nude* (*c.* 1906, *see* page 94) and *Portrait of a Man* (1908, *see* page 95) are examples of his work from the life class, and his *Head: From the Antique* (*c.* 1908, *see* page 96) is an early example of his work in the antique class. One of the class tutors at the college was Adolphe Valette (1876–1942), a French Impressionist painter with an established reputation, who was an excellent teacher. Lowry acknowledged his debt to Valette by saying: 'I cannot overestimate the effect on me at the time of the coming into this drab city of Adolphe Valette, full of the French Impressionists, aware of everything that was going on in Paris. He had a freshness and a breadth of experience that exhilarated his students.'

In 1907 Lowry visited the large exhibition of Impressionist paintings in Manchester, which included works by Monet, Morisot, Pissarro,

Renoir, Degas and Manet. The themes and techniques of the Impressionist painters were clearly very much in the forefront of the thinking of art students in Manchester at that time. According to accounts by fellow students, Valette found it extremely difficult to teach Lowry and eventually let him go his own way while at the same time continuing to encourage and support him. Lowry's *Landscape* (*c.* 1912, *see* page 66) and *Country Lane* (1914), clearly show Valette's influence.

Industrial Vision

According to interviews Lowry gave in later life, he hated Pendlebury at first but gradually his vision for basing his painting on the area developed: 'At first I disliked it intensely … then after a year or two I got used to it and then interested in it and then, I got obsessed by it and practically did nothing else for 25 or 30 years.' In 1912 he saw

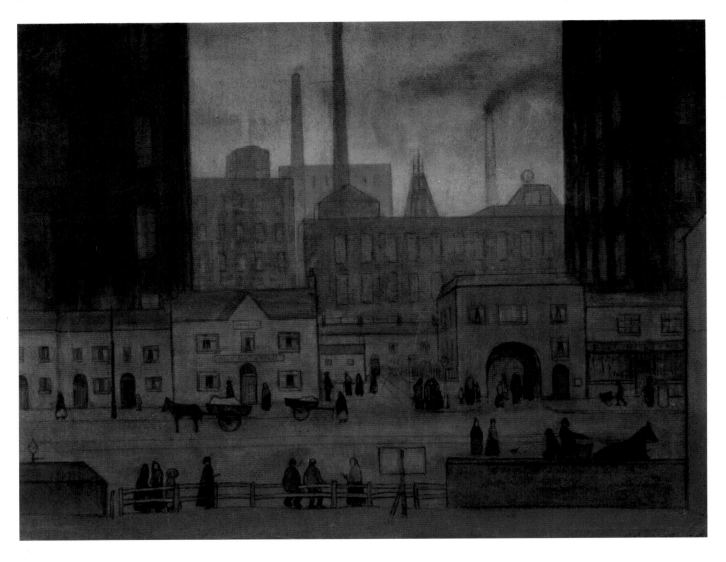

the play *Hindle Wakes* by Stanley Houghton (1881–1913), a hard-hitting story of the relationship between a mill owner's family and working-class people in the fictional Lancashire town of Hindle. Lowry was very struck by this work and recalled that this was the first time he saw beauty in the industrial surroundings of the mill towns. He was clearly searching for something original to pursue and to find a niche that would be largely his own.

Lowry's early works reflect his growing interest in the portrayal of the industrial landscape and its people. His first *Mill Worker*, a work in pastel, is dated 1912 and even earlier works dating from 1910 of views of Clifton Junction show a line of factory chimneys on the horizon. Lowry often retold the story of a key moment in the development of his vision. At around four o'clock on an afternoon in 1916 he had missed his train into Manchester and so went back up the station steps. When he reached the top he saw the Acme Mill with yellow illuminated windows shining out in the damp afternoon air, 'A large square red block with little cottages running in rows up to it.' Looking back in later years he wondered whether there was any particular atmospheric condition that showed it in a different light, but 'suddenly I knew what I

had to paint'. From around that time his vision crystallized and increasingly became his motivating artistic force. He said: 'My ambition was to put the industrial scene on the map because nobody had done it … and I thought it was a great shame.'

Continuing Studies

In 1915 Lowry enrolled in the life-drawing class at Salford School of Art and in 1918 he was accepted into the life class at the Manchester Academy of Fine Arts, where he continued to develop his skills while simultaneously working on his burgeoning industrial vision. *Coming from the Mill* (*c.* 1917–18, *see* page 30) reveals an early industrial landscape on a favourite topic that would recur in Lowry's works. The colour palette is as yet not the one Lowry was to develop and use regularly – in particular the colour white is little used. One of Lowry's tutors at Salford School of Art, who was also an art critic for the *Manchester Guardian*, was Bernard D. Taylor, one of the first people to recognize Lowry's originality and potential. Lowry showed him some of the pieces he had been working on. Taylor reputedly declared: 'This will never do' as he held up the works against a dark background to show that the images were too indistinct. Lowry was by all accounts very annoyed and returned home, produced two pictures of dark figures on a totally white background and took them back to Taylor. He was taken aback by Taylor's reaction: 'That's what I meant. That's right. That's perfectly right.' Lowry, by his own account, was furious but realized eventually that Taylor was indeed right. The use of the white background made the figures stand out, as this lighter background threw the figures into relief so that all did not merge together.

In 1924 Lowry conducted an experiment in which he painted a small piece of wood flake-white six times. He then let it dry, sealed it up and left it for six or seven years. At the end of this period he did the same with another piece of wood and then compared the two. 'The recent one was, of course, dead-white, but the first had turned a beautifully creamy grey-white. And then I knew what I wanted. So you see, the pictures I have painted today will not be seen at their best until I'm dead.'

First Exhibition

Although Lowry's works had been shown at the Manchester Academy of Fine Arts in 1919, his first public exhibition was in 1921 at the offices of the architect Rowland Thomasson in Mosley Street in Manchester. Thomasson and a friend, Tom H. Brown, showed 30 watercolour works between them. Lowry showed 25 oils and two pastels. The exhibition lasted two weeks and not one of Lowry's works was sold; nowadays they are in collections all over the world. *The Lodging House,* 1921 (*see* page 31) was for sale at 10 guineas and was later bequeathed to Salford Museum and Art Gallery. This early exhibition covered most of the topics that Lowry would develop over the

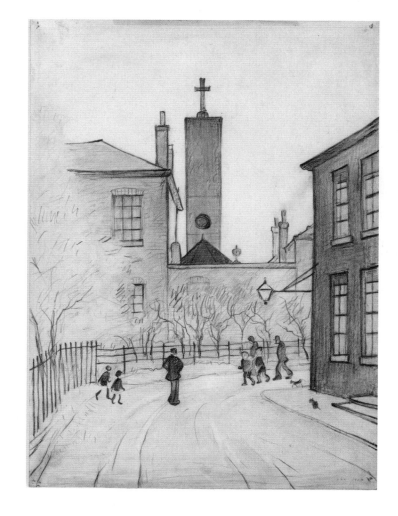

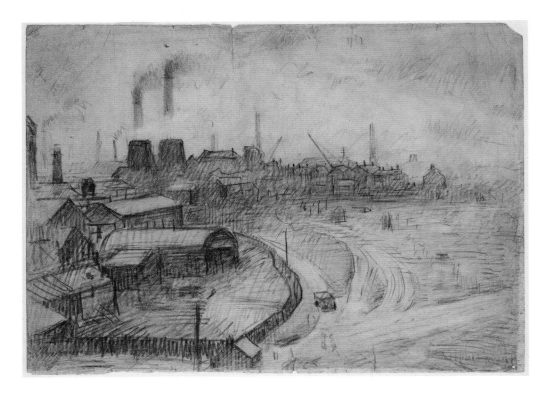

school's tutors, the art critic Bernard D. Taylor. Taylor allocated more than three-quarters of his half-column to the works of Lowry, whom, he wrote, had 'a very interesting and individual outlook'. He continued by saying that Lowry's works had 'real imagination', and were done 'with the intimacy of affection'. Acknowledging that Lowry had depicted everything that industrialization had done to make Lancashire forbidding, and that he had rejected 'all comfortable delusions', he proclaimed that Lowry had a fresh vision. As to Lowry's figures, he considered that the crowds 'which have this landscape for their background are entirely in keeping with their setting', and the incidents in which they are involved 'are also appropriate'. He also highlighted that, in his opinion, the pictures were created not by 'references to established conventions but by sheer determination to express what the artist has felt, whether the result is according to rule or not'. Clearly this was a breakthrough point for Lowry; a write-up in a well-respected, widely read newspaper by a critic who liked his work and also seemed to understand it.

rest of his life: mill scenes; incidents, such as a man taken ill or a quarrel; scenes with many people, such as one that depicted people shopping and one with children coming out of school and making their way home; street orators; landscapes; and even a nod to his interest in the sea in the portrayal of fishing boats. Also included was a portrait of an old man, the only area of work shown in this exhibition which Lowry decided eventually not to continue with, that of the serious portrayal of named individuals. After the reception of the portrait of his friend, Frank Jopling Fletcher (1919, *see* page 106), whose family disliked the work intensely, Lowry decided to give up the genre, saying he could never make people look happy. However, he did complete *Self-Portrait* (1925, *see* page 110) in which he looks out at the viewer with steadfast, determined gaze and throughout his life he depicted many individual characters and even made caricatures of customers and colleagues.

Review

The exhibition in Mosley Street was significant for another reason. It received a review in the *Manchester Guardian* by one of the art

Taylor's summary was that Lowry had found his niche in portraying the industrial landscape, that his style of doing so was original, that his 'sheer determination' to carry this vision through would prevail, that figures in his works were of great significance and, perhaps most importantly, that Lowry had an affinity with his subject. The emotional impact of the move to Pendlebury and his daily encounters and visual experiences in the rent-collecting rounds in the back streets of Manchester, had been an emotional and psychological journey for Lowry but one which, despite the original effect of shock and disorientation, eventually aroused sympathetic understanding and responses in the artist who would depict these scenes for posterity in his own poetic way.

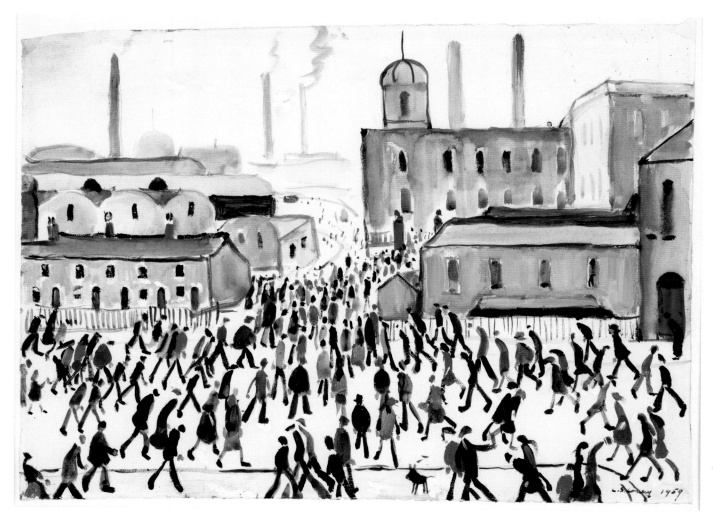

The Industrial Landscape

From his early works of 1910 to those of the late 1930s, Lowry painted and drew the scenes he saw around Manchester and Pendlebury. His vision was intense and focused; he had decided to paint the industrial environment and pursued this aim with a dogged determination despite the overall lack of appreciation of his contemporaries, his tutors, his mother and potential buyers of his works, who were few and far between. The wealthy residents of Manchester seemed to be amazed that they might be expected to part with their money to buy a depiction of an unpleasant district, which they could see in the flesh if they took a simple journey to the other side of town. The 1920s were Lowry's most prolific period; in particular he created a large body of drawings of the industrial surroundings in which he found himself. The drawings are detailed and accomplished, and furnish a record of the mills with their surrounding terraced houses and inhabitants.

Crowds and Figures

Lowry's industrial scenes are frequently full of crowds; anonymous figures going here and there often leaning forward with heads down, bracing themselves against the wind and the elements, or simply moving onwards with a singular determination to get to their

destination. Sometimes they seem akin to a giant ant heap, a mass of moving human life as in the Peel Park pleasure scenes. It is a strange conundrum that someone like Lowry, who was something of a loner, should be so engaged in depicting crowds. Perhaps that is how he saw himself, on the outside looking in at what others were involved in. The characteristic figures that he developed are dark, thin and elongated, almost silhouettes, which were given the name 'matchstick men' by a critic, a term that Lowry disliked but one which caught the public imagination and clearly sums up for many people the image of Lowry figures.

Architecture

Many of Lowry's drawings concentrate on the architectural features and details of buildings. *Oldfield Road Dwellings* (1929, *see* page 46) shows a characteristically unusual and visually rich block of homes built for workers leading up to and rounding a corner of a street. The mid-1920s series of *Leaf Square* drawings (*see* pages 38 and 39) increased Lowry's architectural vocabulary, as did *The Flat Iron Market* (*c.* 1925, *see* page 35). His views from the window of the Royal Technical College in Salford further developed the close depiction of architectural features (*see* pages 32 and 36). Churches challenged his skills of depiction with their specific architectural features and ecclesiastical detailing. *A Street Scene (St Simon's Church*, 1927, *see* page 44) was developed from a sketch on the back of an envelope, which he expanded to encompass the mill in the background, the lampposts and the people. His painting of the same scene (1928, *see* page 45) was worked up from the drawings. The church was surrounded by mills and engineering works and situated close to the River Irwell. It could hold 1,000 people but by 1923 its tower had been partly taken down as it was in poor condition. Lowry was persuaded by his father to draw the church. At first he was not interested but his father persisted, telling him: 'You'll really have to go and see St Simon's Church; it's your cup of tea and it's coming down very soon.' When Lowry returned later in 1928 he found the church had indeed gone. *By St Philip's Church, Salford* (1926, *see* page 43) enabled him to depict the church tower together with a distinguished house, the corner of a larger building with a Regency window and also a row of terraced houses.

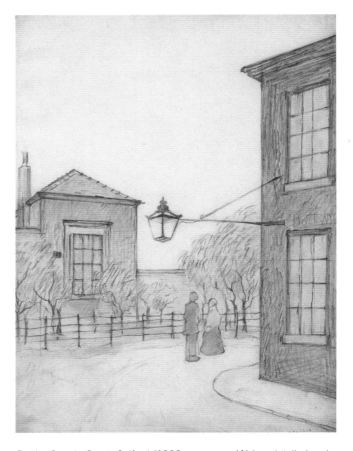

By the County Court, Salford (1926, *see* page 41) is a detailed and sophisticated example of the topographical recording of buildings. *Coming from the Mill* (1930, *see* page 49) was considered by Lowry to be his most characteristic mill scene. Based on his much earlier work of *c.* 1917–18 (*see* page 30), this shows a marked contrast in style, the main change being the use of the white background.

The Countryside

As well as his work in the town, Lowry continued his walks in the surrounding countryside; the relationship between town and country always held a fascination for him. *Wet Earth Colliery, Dixon Fold* (1925, *see* page 34) highlights the effect of the encroachment of the industrial age on the countryside. *Country Road* (1925, *see* page 68) is an example of an open country landscape. Such scenes of the countryside were instrumental in Lowry receiving a commission from

the writer Harold Timperley (1890–1964) to illustrate a book Timperley was writing for the publishers Jonathan Cape. This was published as *A Cotswold Book* in 1931. Here Lowry could use all his skills of observation and topographical study; the resulting 12 drawings are detailed, effective and atmospheric. Timperley gave Lowry £30 (about £1,200 today), no doubt a welcome addition to his finances but not a great deal for the work involved, and Lowry did not seem interested in pursuing the art of book illustration further. For Timperley's further commission, *Shropshire Hills*, Cape insisted on photographs for the illustrations.

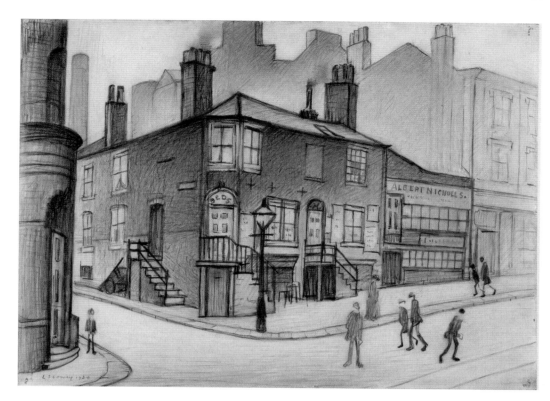

The Countryside in the Town

The theme of the countryside in the town was one that Lowry clearly enjoyed portraying and which he developed in a number of works. Peel Park was a part of Salford, which seems to have been much loved by Lowry. Lark Hill Estate, with its mansion, had been purchased by Salford Borough Council in 1846 and was one of three public parks opened that year in Manchester and Salford. It was named after Sir Robert Peel, the prime minister, who had been born in nearby Bury. The mansion became a museum and free library, and an additional extension was added to the building in 1853. The park area is bordered by a river, which gives an even more rural feel to the surroundings. Lowry made a number of drawings and paintings of the park and its buildings, drawing on its rich examples of nature and man-made constructions. His drawing, *Bandstand, Peel Park, Salford* (1925, *see* page 67), which he later developed into a painting, is

executed with care and painstaking detail. The use of a simple pencil creates a multitude of effects and nuances, from the dark area of trees on the right to the hazy background sky of the industrial chimneys. The figures are drawn to the almost mesmerizing feature of the bandstand, enjoying an important aspect of recreation in an era before the universal availability of radio or television. In his painting *Peel Park, Salford* (1927, *see* page 69), created before Lowry adopted the use of white as his main background colour, the overall effect is sombre and dark with the main image merging with the background. *The Terrace, Peel Park, Salford* (1927, *see* page 70) and *The Steps, Peel Park, Salford* (1930, *see* page 71) offer two more perspectives of Lowry's work in this clearly much-loved place.

Glimmers of Commercial Success

Interest in Lowry's works was gradually beginning to develop and in 1926 Manchester Art Gallery bought one of his 'incident' works, *An Accident*, 1926. More public exhibitions were taking place and his work was shown

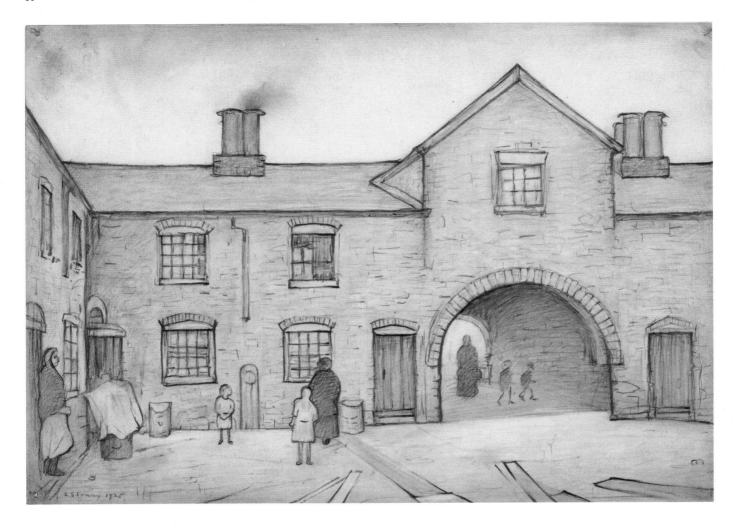

at the Manchester Art Gallery and the Harris Museum and Art Gallery, Preston. Reproductions of his work were also used to illustrate articles in the *Manchester Guardian*. *The Quarrel* and *A Manufacturing Town* appeared alongside an article on 'Textile Finishing' in the edition of 2 October 1926. Clearly Lowry was beginning to be acknowledged as the artist who was working on depicting the industrial city in a way that was neither destructive nor sentimental, but with poetic and artistic skill. Two of the chief officials at the Manchester University Settlement approached Lowry to draw the district of Ancoats, a particularly run-down area of the city that had been singled out for improvement. Lowry produced 25 drawings, including *Great Ancoats Street, Manchester* (1930, *see* page 47), which were shown at a two-day exhibition at the University

Settlement and which were all sold by the end of the show. It was also in 1930 that the *Manchester Guardian* ran an article, 'Mr Lowry in Ancoats', followed by an invitation for Lowry to write art criticism for its pages. He recalls that he and his mother laughed and laughed about this invitation, both knowing that he was certainly not cut out to be a writer. Needless to say, he turned down the offer.

A Star Ascendant

From 1928–38 Lowry's works were exhibited regularly at the Paris Salon d'Automne and Société des Artistes Français. How *had* this come about? Bernard Taylor's early favourable review of Lowry had

created a ripple effect. As Lowry's reputation grew, he began to be noticed by other galleries. W.H. Berry, the director of the Oldham Art Gallery, invited him to Sunday lunch. This proved to be a pivotal point in Lowry's career as Berry's wife, Daisy Jewell, was the head of the framing department of the London-based company of James Bourlet & Sons, a supplier of services to artists such as framing, packing, storage and transportation of works of art. Jewell was very interested in Lowry's work and made it her mission to promote him in London where she worked during the week. The director of Bourlet, Armand Blackley (1891–1965) also became a Lowry supporter and from 1923 onwards he and Jewell worked tirelessly to make Lowry better known, sending

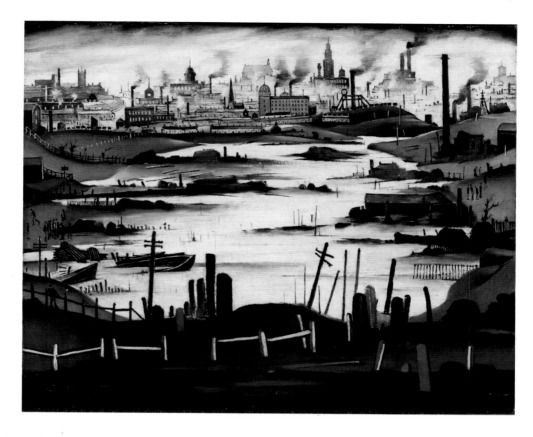

his works to France – which accounts for the five showings at the Salon – and also making sure they were seen at exhibitions around Britain. None of the works sold but this early exposure was critical to Lowry becoming better known in the art world.

Difficult Times

In 1932 Lowry's father died suddenly, leaving Lowry to discover the extent of his debts. Robert Lowry had clearly struggled for a considerable period to make ends meet. Lowry was shocked and surprised by what he found among his father's papers but accoring to Shelley Rohde's biography of Lowry, within a few months he had settled everything. While not earning a lot from his painting, he had been prudent with his regular steady income and had sufficient reserves to sort out his father's financial problems. Elizabeth Lowry reacted badly to her husband's death and took increasingly to her bed, eventually being described as 'bedfast' – whether from choice or necessity is unclear.

Elizabeth didn't take kindly to other helpers, preferring her son to care for her. So Lowry worked for the property company in the day, came home and looked after his mother in the evening, and only when she fell asleep did he go to his workroom to paint. Such a draining schedule eventually took its toll and very few paintings among Lowry's works date from this period. The paintings that survive from these years often reflect the strain and pressure Lowry was under. He began to paint what have been called his 'lonely landscapes'. *A Landmark* (1936, *see* page 72) conveys the theme of total isolation. *The Lake* (1937, *see* pages 50–51) seems to symbolize the industrial north of the 1930s wreaking its havoc on the environment, polluting the atmosphere with its smoke and soot, creating a deeply depressing scene of desolation, possibly reflecting Lowry's mental state at this period. *Head of a Man* (1938, *see* page 113) was painted shortly before his mother died. The wild, penetrating red eyes reflect inner torment. In an interview Lowry confessed that this work was a self-portrait. 'I was out of my head in those days…. It was just a way of letting off steam, I suppose.'

Increasing Recognition

Lowry's reputation continued to rise and in 1932 his works were shown at the Manchester Academy, and he accepted an invitation to join the institution in 1934. In the same year he was also elected a Member of the Royal Society of British Artists and further reviews praised his work: 'By far the most creative of the landscapists is Mr Lowry…. He paints chimneys as Lorenzo Monaco painted saints.' During 1938 Lowry was preparing for his first solo exhibition, which was to be held in London; his star was now in the ascendancy and his mother could see, if she wanted to, that others were acknowledging her son as a significant, important artist. She did not live to see him achieve the highest level of success, however, as she died in October 1939 in her 83rd year. Lowry was bereft, distraught. 'What is there left?' he would say over and over again to his colleagues in the office. What was the point in being successful if she wasn't there to share it? What was the point in stunning sales figures if she didn't know of them? In later years Lowry would say that it all came too late for his mother to know of it. 'I had no need to paint after she died,' he said many years later, still reiterating his need to prove himself to her. It took a number of months before he began to paint again and, when he did, it helped to ease his grief and fill his empty hours. At the age of 80 he was to say: 'I've not cared much about anything since she died. I've nothing left and I just don't care. Painting is a wonderful way of getting rid of the days.'

Breakthrough

The solo exhibition, which was to prove a breakthrough for Lowry, was held in January 1939, a number of months before the death of his mother. Daisy Jewell was the key to this breakthrough. Still tirelessly working on Lowry's behalf, she received a visit early in 1938 from A.J. McNeill Reid (b. 1893), a director at the Lefevre Gallery in central London. She departed from her usual scrupulously tidy habits and left some of Lowry's works propped up in the office. Her tactics worked. McNeill Reid noticed them and said that if his business partner liked them they would have a show. They were, indeed, liked and the show went ahead although, interestingly, the northern aspect was played down, with the gallery calling the show 'Paintings of the Midlands'. Jewell recommended that 16 critics should receive personal invitations from Lowry himself. One of these was Eric

Newton (1893–1965), who in turn was to become an ardent Lowry supporter, by 1945 referring to Lowry as a master, a mystic, and a poet. Not everyone was so enamoured. Michael Ayrton (1921–75) of *The Spectator* declared: 'I resent the Lowry automaton.' Sales from the show were more than Lowry had dared to expect, with 16 works selling at around £30 each. The most exciting development was that the Tate wanted to buy *Dwellings* (1927). Lowry's confidence was boosted and he commented that 'it made me feel that I had justified myself to my mother'.

War Work

During the Second World War Lowry worked two or three nights a week as a firewatcher on the rooftops of the large department stores in central Manchester. The city endured heavy bombing and almost 70 per cent of its Victorian and Edwardian buildings were destroyed. St Augustine's Church was devastated during an air raid and Lowry would later go on to paint the ruins in 1945. Despite wartime restrictions, Salford Museum and Art Gallery ran a solo exhibition entitled 'Paintings and Drawings by Laurence S. Lowry' in 1941, and in 1942 Lowry was appointed an official War Artist. He did not produce many works and it seems that the committee was rather irritated by this lack of results. He did produce *Blitzed Site* (1942, *see* page 53), one of his rare depictions of a wartime scene. He was asked to produce a painting of factory life by the War Artists' Advisory Committee and the result was *Going to Work* (1943), now in the Imperial War Museum collection. It is a typical Lowry industrial scene with large buildings and crowds of people arriving for work at the engineering firm of Mather & Platt Ltd, Park Works, Manchester with the only reference to the war being the barrage balloons. In 1945 Lowry received a commission from the Artists' International Association to paint the celebrations on VE Day, which marked the end of the Second World War in Europe. Against a backdrop of massive industrial buildings decorated by flags and bunting, crowds joyfully celebrate, dancing in the street and rejoicing.

Technique

For the most part Lowry painted in oils with a few works in watercolours. From early on, he had chosen to work in just five colours: ochre, blue, black, white and red. For a large part of his career when living at home

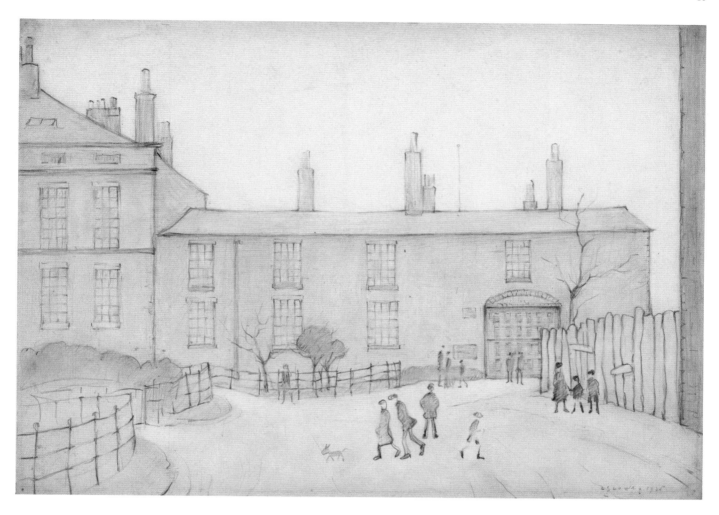

with his parents Lowry would paint at night in the attic, relying on artificial light, so this may have affected his colour palette. He frequently used a variety of tools to create effects: a pallete knife, his fingers, his nails, sharp instruments to scrape the paint surface, or he would simply rub away areas to create a variety of tonal effects. He would cover the board or canvas in white, leave it for a week or so and then sketch outlines in pencil or charcoal.

For his drawings Lowry would mostly use a soft pencil, varying the depths of tone by using his finger or the ball of his thumb to rub and smear the surface, and also a rubber to lighten areas. Such smudging was helped by the use of what the Manchester College of Art students called the 'stump', a piece of blotting paper rolled and used as a pencil. In later years Lowry would sometimes use a ballpoint pen or felt tip. Some early drawings were made in pastels and crayons, which lightened the palette considerably and were used to good effect, particularly in his seascapes.

The Post-War Era

After the war Lowry's works continued to be increasingly displayed in exhibitions. Sales were steady and while still polarizing opinion amongst critics, Lowry's star continued to rise. He began to travel more to various parts of Britain, developed close friendships with patrons,

attended the theatre and concert hall, and visited friends. The house in Pendlebury became neglected, and in 1948 Lowry bought a house in Mottram-in-Longdendale in Cheshire. He insisted that he disliked the house (known as 'The Elms') and the area intensely, but he continued to live there until his death.

Britain's industrial decline was now gathering momentum and the old ways were changing. Areas were being demolished, people were being rehoused and the old communities were breaking down; the industrial landscape as Lowry knew it and had portrayed it was disappearing. In some ways this was to Lowry's advantage as an artist because what he had portrayed in the 1920s and 1930s, which people at the time took for granted, was now being gradually swept away. Lowry was seen to have preserved in art a way of life that at the time was nothing unusual, but now was passing into history. He continued to create industrial landscapes but they were frequently re-workings of previous themes or a response to the industrial decline. In 1945 he was amazed to receive an honorary degree from Manchester University. Professor T.W. Manson (d. 1958) who presented the degree

called him '… a Lancashire artist of rare distinction…. His work is marked by a ruthless sincerity which prevents it from falling into mere prettiness or sentimentality: while the artist's obvious and deep affection for his subjects ensures that the picture, however grim, shall never be sordid. He confers beauty on the seemingly unattractive by the affectionate understanding which he brings to its portrayal.'

Commissioned by the newly created Arts Council, Lowry painted *Industrial Landscape River Scene* (1950) for the Festival of Britain exhibition '60 Paintings for '51', which aimed to encourage public collections to purchase pictures that reflected the British way of life.

Retirement from Pall Mall

After 30 years Lowry was tiring of the industrial scene and with his retirement from the Pall Mall Property Company in 1952 he had more free time in which to travel, particularly visiting the north-east and observing the sea. He was invited by the Salford Museum and Art Gallery to record local areas before they were redeveloped. In 1956 this request resulted in, among others, drawings of *St Stephen's Church, Salford* (see pages 56 and 57), which was demolished in 1958, *Christ Church, Salford* (see page 58), *Francis Terrace, Salford* (see page 59) and *North James Henry Street, Salford* (see page 62). He also made a number of trips to Wales with his ardent admirer and patron Monty Bloom, where his interest was stimulated by mining villages, resulting in such works as *Ebbw Vale* (1960). In 1957 the BBC made a documentary about Lowry that was watched by two million viewers and which brought him to a much wider audience. Numerous honours came

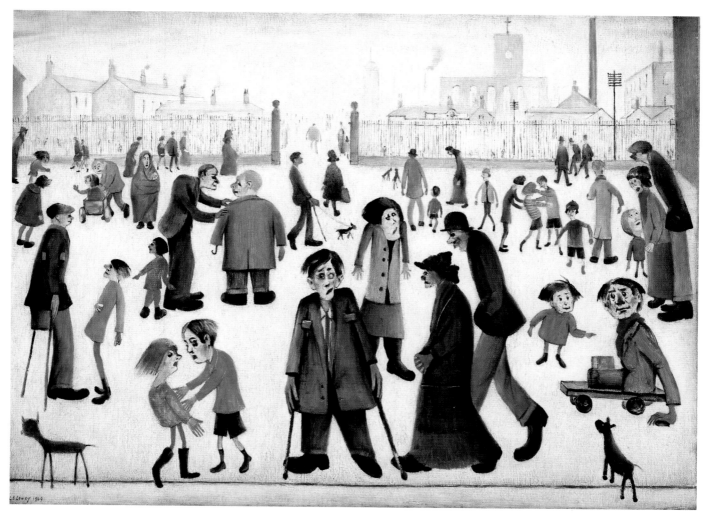

Lowry's way in this later period. In 1965 he received the freedom of the City of Salford and in 1975 he received two honorary degrees from the University of Salford and the University of Liverpool. He turned down an OBE in 1955, a CBE in 1960, in 1967 the offer of a knighthood and in 1971 the Companion of Honour. Lowry explained in an interview that he was shocked to have been offered these honours: 'I'm not a socialist; I'm a good Conservative. But I didn't want a title.'

People

Cut off from the chimneys and mills of the city and retired from the Pall Mall Property Company, Lowry was deprived of the milieu that had been his inspiration. He said: 'The strange thing is that when the industrial scene passed out in reality, it passed out of my mind.' He was to find new inspiration in people, the inhabitants of the town scenes he had portrayed before, but now close-up and in detail. He had produced some prototypes of these works earlier in his career, one such being *On the Sands* (1921, *see* page 108), a study of individual figures. Now he began to look more closely and developed this aspect of his art, again not without criticism. *The Cripples* (1949, *see* page 118) was a composite work of a variety of people with disabilities, which some objected to as being cold-hearted, as it is quite without sentiment. Lowry rejected these criticisms, referring to the time he suffered profound stress and depression while looking after his mother,

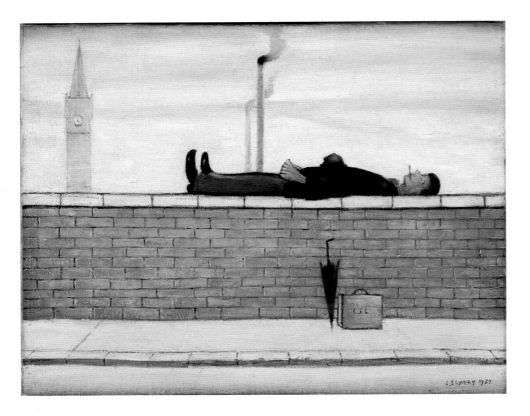

humorous tone. Lowry claims to have seen this scene one day as he was travelling on the top deck of a bus and he recalls he found it very funny. Lowry put his own initials on the man's briefcase, perhaps to suggest a common identity with him, shunning social norms and acceptable practices and going his own way, doing what he felt like doing. Lowry produced a number of works with a single figure against a white background, usually engaged in an activity, such as *Gentleman Looking at Something* (1960, *see* page 123). Characters were scrutinized and were usually the subject of exaggeration, making them look somewhat foolish. Lowry was to say: 'There's a grotesque streak in me and I can't help it. They are people, sad people; something's gone wrong in their lives. I'm attracted to sadness.' He was also to say that he was interested in 'the sordidness of down-and-outs ... what they have become, and in how their defeat and poverty have helped to isolate them, to set them apart, and give them the curious, often comical look that interests me.'

saying he knew what it is to want to commit suicide. After his recovery Lowry could look without sentiment but with compassion on the 'strange, sad figures ... who came to inhabit his later canvases'. He was known to say regularly: 'There, but for the grace of God, go I.' Often he would include a figure in a crowd which perhaps represented himself, the artist, such as the tall man walking his dog in the middle ground of *The Cripples*, passing through the scene but not quite of it.

A Sense of the Absurd

Humour, or perhaps more accurately the sense of the absurd or even, one could say, satire, came to be a hallmark of these works. *The Funeral Party* (1953, *see* page 116) takes a group of people with something in common but who appear totally separate and disconnected; the loneliness of the group but represented in a comic yet strange and sad way. *Family Group* (1956, *see* page 117) also underlines the separateness and the oddity of the family members. *Man Lying on a Wall* (1957, *see* above and page 120) has more of a

The Sea

One area of work for which Lowry is little known, but which contains some very attractive pieces, is that of his seascapes; the earliest surviving drawing by Lowry is *Yachts* (1902). The sea is a topic to which Lowry returned time and again during his career and was the part of his work that his mother really liked. After having expressed her disapproval of industrial scenes, Lowry asked her what she would like him to paint; she is said to have replied 'the yachts at Lytham St Anne's'. *Yachts* (1920, *see* page 82) is a delicate, impressionistic work in pastels, peaceful and restful with a vast sky and wide expanse of water in cool blues. *Sailing Boats* (1930, *see* page 83) uses a browner palette of

colours and is more of a close-up image of the boats themselves. This was his mother's particular favourite and Lowry treasured it after her death, knowing that this work had her approval. *Yachts* (1959, *see* page 90) is a delightful study in creams and yellows with a sun-streaked sky, plenty of activity on the water and a variety of people and dogs on the sands. This could almost be described as a happy picture by Lowry, although the character on the far right has his back to all the others and is hunched over; the artist himself? His *Seascape* (1952, *see* page 86) has neither boats nor people, being more of a study in horizontals and use of colour and gradations of tone. *The Estuary* (1956–

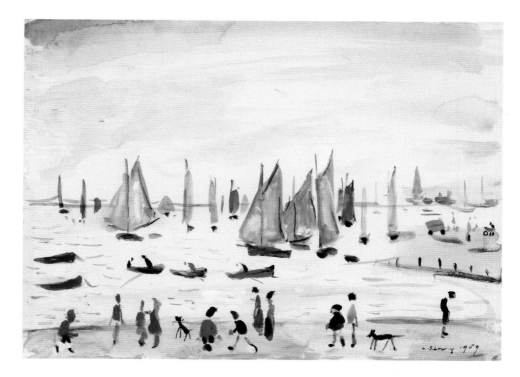

59, *see* pages 88–89) is less impressionistic with the use of dark colours and clean lines. In all Lowry's sea pictures the use of white is notable and whatever sea-themed topic he took, there was plenty of opportunity to use and exploit his favourite colour.

The Social Paradox

After a childhood in which he was described as awkward and odd, something of an outsider, Lowry developed a number of social friendships as an adult. At the Pall Mall Property Company he was popular, went walking and to concerts with colleagues, and was a well-loved employee of this family business. When he became well-known he was allowed time off to travel to London to tend to artistic affairs, and his close-knit circle of colleagues kept his employment there a secret, as Lowry wished, probably because he did not want to be labelled an 'amateur' who only painted in his free time.

The paradox of Lowry is contained in these seemingly opposite traits; the outsider, tall and ungainly, uncomfortable, a seeming 'loner' not actively seeking out people, but on the other hand sociable, with a number of

colleagues and friends with whom he went walking and to cultural events, and in the years of his success, the social invitations and encouragement of his patrons and supporters. He had a tendency to keep his patrons and supporters separate from each other so that each did not know of the other. They frequently thought he was lonely and isolated and, indeed, he would say he was, which may well have been the case when he was at home on his own, forever working at his art or listening to his beloved Vincenzo Bellini (1801–35) or Gaetano Donizetti (1797–1848). Maybe this 'separation' of his patrons, so that each was for the most part unaware of the others, was a wise ploy in the fickle world of the art business where fame and profit were linked, and where artists could be seen as a commodity to create business and profit but could then be discarded if things did not work out as planned. Certainly, in some of his later works people start to be given faces of dogs and animals, as if the rapaciousness of the wider world was attacking him. Indeed, Lowry was to say when pestered for more industrial scenes or when galleries were involving him in their rivalries to acquire his works: 'Well! – don't you think I've had enough? What more do you want from me?' By contrast, Lowry was often welcoming to the many people who called at 'The Elms' to talk to him, to ask him to sign and date works or to solicit his support.

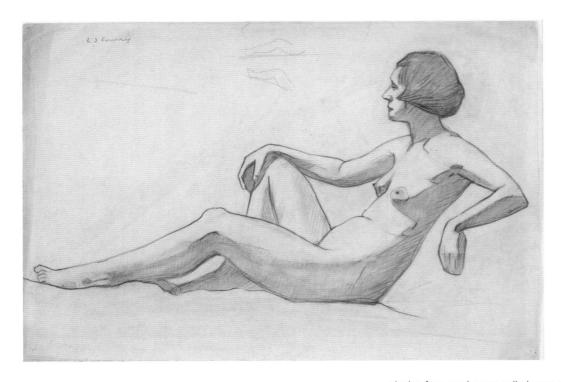

as one of the witnesses at the wedding of Doreen Sieja who worked in the Pall Mall office, the other witness being her father.

Ann

A somewhat unsettling feature of Lowry's character and imagination seems to have been the invention of an imaginary relationship with a young woman who had had a wonderful but short career as a ballerina, was from a cultured and wealthy family and who lived for much of the time in Italy. It seems that the elusive Ann, as she was called, may most likely have been an amalgamation of a variety of women Lowry had known, and to have represented for him an ideal woman with whom he could occupy his thoughts and talk about to his friends. *Portrait of Ann* (1957, *see* page 121) shows her with the typical ballerina hairstyle, parted in the middle and scraped back from her face. She appears unreal, detached, with a forbidding and cool expression. When he was a wealthy man, Lowry, who had always had a fascination with the Pre-Raphaelites, bought a number of paintings of women by Rossetti (1828–82) that he hung in his bedroom, and which perhaps in a different way perpetuated another image of a fantasy, imaginary woman. In an interview Lowry said: 'The Rossetti women are not real women. He used them for something in his mind caused, in my opinion, by the death of his wife.' Perhaps these were the words of a lonely man whose mother had died, who had no wife and no children, identifying with one of his artistic heroes.

Lowry and Women

Lowry's mother, educated and musically cultured, was clearly a powerful force in Lowry's life. Lowry seems to have respected her and looked up to her; whether she discouraged any romantic liaisons is not known. That he became his own man and refused to let his mother dominate his artistic career is clear; if he had pleased his mother he would have painted only the sea and boats in a quasi-Impressionist style. By Lowry's own account, he had opportunities to develop relationships with young women – particularly when he went to art classes – but he always held back. He spoke of one young woman who attended the classes with him and with whom he had become friendly, but when she did not enrol for a new term, that was that; he did not see her again. Clearly not one for following up an opportunity, whether due to shyness or fear of rejection, Lowry did not pursue his chances. As he grew older he became something of an 'uncle' figure for a number of younger women, taking them out to concerts and giving them presents, but these relationships were always conducted with propriety on Lowry's part. He was always pleased to meet their boyfriends and attend their weddings, even acting

Protégés

In later years Lowry supported a number of artists in the early stages of their careers, both men and women. He would write references for

them, meet up with them and even support their studies financially. Two significant women figures in this respect were Sheila Fell (1931–79) whose works impressed him at an exhibition and the young Carol Ann Lowry (b. 1944). Carol Ann, who as it turned out was the last of his protégés, had written to Lowry at the age of 13 asking if he would advise her about becoming an artist and wondering if they were related. They were not, as it turned out, but Lowry – whom she came to call 'Uncle Laurie' – took her under his wing, supported her and became the equivalent of a doting godfather. Carol Ann herself said: 'He made me. He moulded me, he fashioned me in the image of Ann and in so doing made me to a great extent like him. I was sufficiently young for him to do it; and sufficiently malleable…. He taught me so much and displayed, by example, the virtues of perception, of humility and humour.'

Lowry never painted or drew Carol Ann, just as he had never depicted any of the other young women he had been associated with, preferring to paint what was possibly the composite of them all: 'Ann'. Carol Ann was to say: 'I think that I was simply the tag-end of what I, for want of a better description, call the Ann thing.' Lowry had no close relatives at the time of his death and given that through his influence he had moulded Carol Ann into the woman she became, it is perhaps unsurprising that Lowry made her his sole heir, leaving her everything that had not been already bequeathed to galleries and other patrons.

A Darker Side

Some critics have seen signs of repressed sexuality in some of Lowry's works such as *A Landmark*

(1936, *see* page 72). In his last months he was to draw *Gentlemen with Little Girl* (1975), which shows middle-aged men ogling a girl in a mini-skirt. More disturbing are the numerous works found after his death, both drawings and paintings, which depict scantily dressed young women in various positions of severe distress. Some of them seem to be caricatures of the fashionable 'dolly birds' of the era; some show a ghostly arm carrying a weapon threatening the girl. The scenes could be ones of bondage, given the excruciating and uncomfortable clothing the girls wear.

Perhaps more unsettling is that in 1998 Michael Howard, the art historian, discovered that Lowry had included some such scenes in other works but had painted over them or hidden them. The tortured girl is hidden beneath seemingly innocent scenes. What these pictures mean is difficult if not impossible to interpret; anger at women who may have hurt him, some kind of inner mental torment? It is unlikely that we shall ever know.

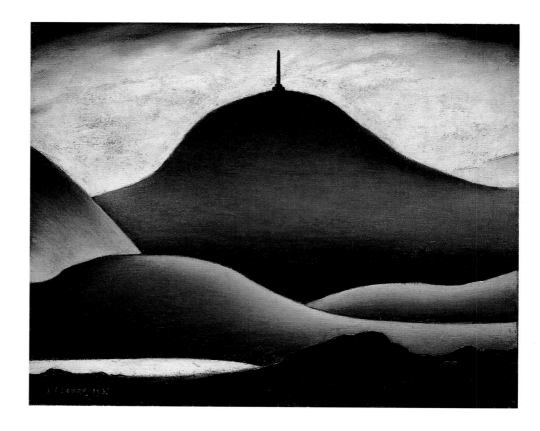

Lowry's Place in the History of Art

Lowry is still a controversial and contested artist. Although seemingly loved by the general public, academics and critics remain divided about him. Some see him in the line of eccentric English artists such as William Blake (1757–1827) and Sir Stanley Spencer (1891–1959), ploughing his own furrow, creating his own style in his own way; nothing particularly came before him and nothing follows on after him. The art critic Waldemar Januszczak (b. 1954) said: 'He deserves to be seen alongside Stanley Spencer, Edward Burra, Lucian Freud as one of the edgy and independent urban realists of the century.' As Lowry becomes increasingly the topic for academic study, serious attempts to place him in an art historical context have taken place. The influence of the Impressionists undoubtedly stemmed from his teacher Valette. Some have compared Lowry with the French painter Maurice Utrillo (1883–1955) whose townscapes have a simple, atmospheric quality. Others have seen affinities with the Expressionist movement, and Lowry himself declared his passion for the Pre-Raphaelites. He is sometimes compared with Pieter Bruegel the Elder (*c.* 1524–69) in his ability to paint crowds of every conceivable type of individual and to represent the oddities of the common man. Bruegel also created representations of the industrial scenes of his day so there are a clear number of affinities between the two artists. As to his topographical works, Lowry can be considered in the line of English landscape artists beginning with Paul Sandby (1730–1809) and his brother, the architect and draftsman Thomas Sandby (1721–98). Lowry should certainly be seen in the historical light of the representation of the industrial past; just as J.M.W. Turner (1775–1851) painted the dawn of the Industrial Revolution, Lowry painted its twilight.

Lowry's Legacy

Lowry died of pneumonia in February 1976, aged 88. Within a year of his death the Royal Academy held a 10-week exhibition of Lowry's works. Long queues formed outside Burlington House and the attendance numbers set new records. In the latter part of the twentieth century it was decided to completely redevelop the area around Salford and turn it into a site with television studios, a branch of the Imperial War Museum and an arts centre with the old Manchester Ship Canal running through the site. Few artists have a cultural centre named after them with a gallery dedicated to their works within.

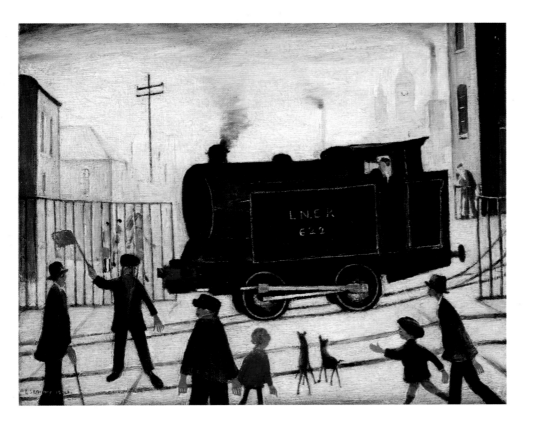

The city of Salford had been collecting Lowrys for many years and so had an excellent store to draw from to furnish the creative centre and gallery – called 'The Lowry' – which was opened in 2000. It houses the world's largest

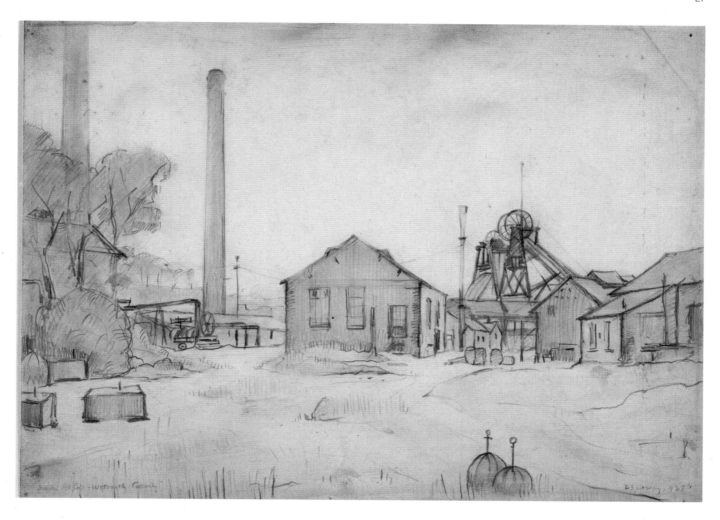

collection of Lowry's art on public display, with over 400 works in its possession. Alongside this, The Lowry also contains an impressive archive of photographs, exhibition materials and excerpts from the press, all transferred from Salford Museum and Art Gallery. It acts a centre for continuing the promotion of L.S. Lowry as an internationally renowned artist, as well as a focus for the study of his art.

That Lowry was a local boy who made good is without doubt and he is championed for it. In 2014 a Lowry exhibition was held in China, a country that has been experiencing an industrial revolution of its own with the attendant challenges of pollution and the spread of industrial buildings, which clearly resonates with Lowry's depictions of the industrial north in the early part of the twentieth-century. With a steady number of research articles dealing with Lowry as an accomplished artist, his works are increasingly being taken seriously and studied in detail and in depth.

His works now sell for thousands, sometimes millions, of pounds: for example *The Football Match* (1949), which sold for £5.6m in 2011. Far fewer people are calling him naïve or a Sunday painter, and many more recognize that in his stunning representations of the industrial landscape Lowry was a master in his own accomplished technique and style, offering a unique, compelling vision in poetic terms of a fast disappearing world.

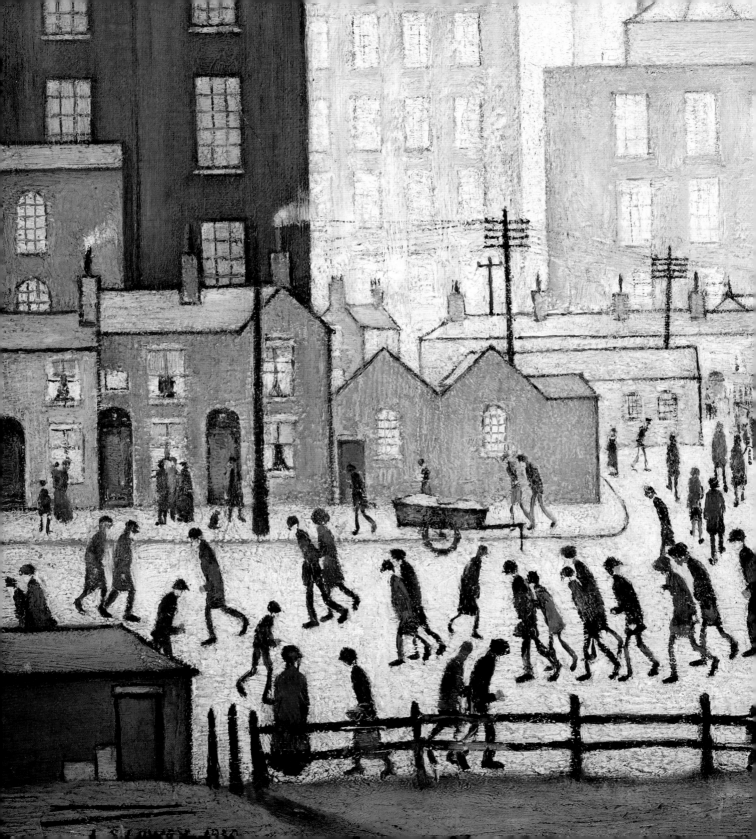

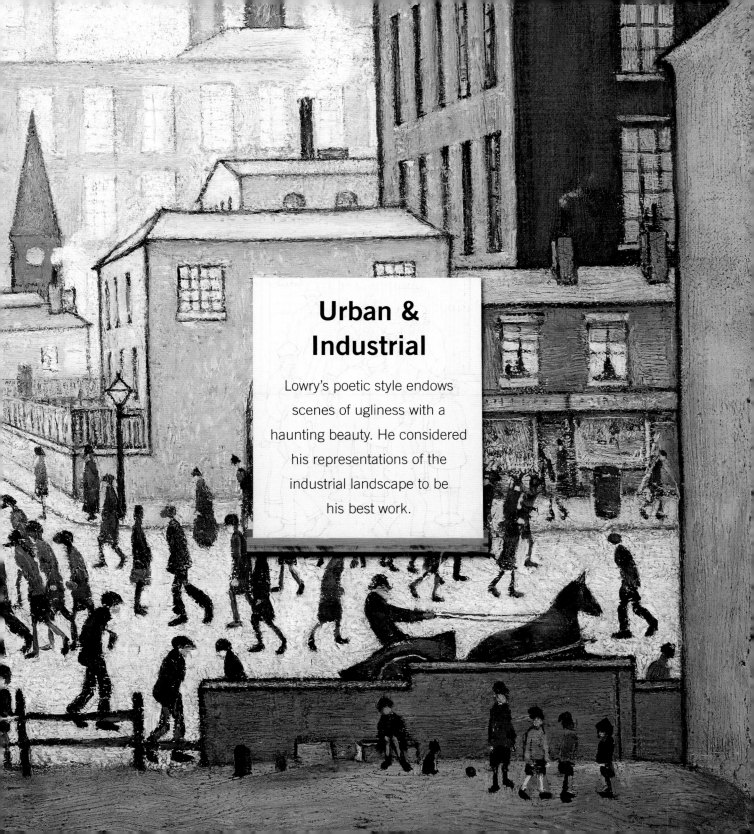

Urban & Industrial

Lowry's poetic style endows scenes of ugliness with a haunting beauty. He considered his representations of the industrial landscape to be his best work.

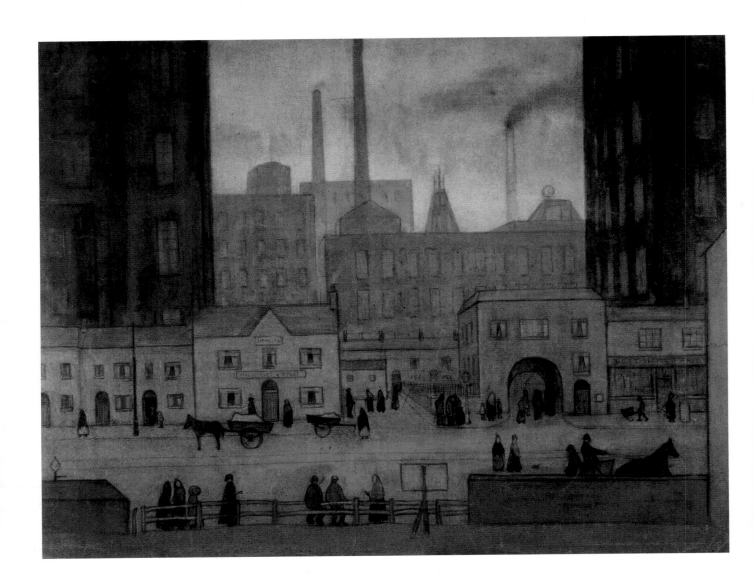

Coming From the Mill, *c.* 1917–18
Pastel on paper, 43.7 x 56.1 cm (17⅛ x 22 in) • The Lowry, Salford

This is one of Lowry's earliest industrial scenes created before he began to use a white background, with more detailed and rounded figures. The horse and cart show some influence of his teacher, Adolphe Valette.

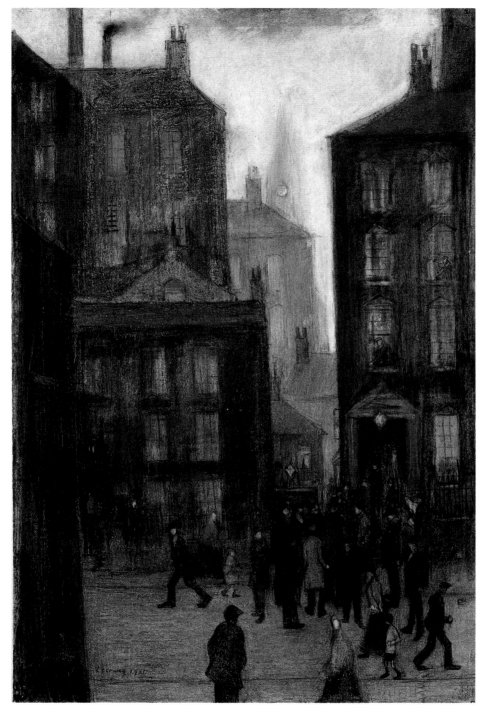

The Lodging House, 1921
Pastel on paper, 50.1 x 32.6 cm (19¾ x 12¾ in) • The Lowry, Salford

This is one of Lowry's earliest 'incident' pictures. Lowry recalled that this was the first picture he ever sold: 'It was to a friend of my father's…. He gave me £5 for it.'

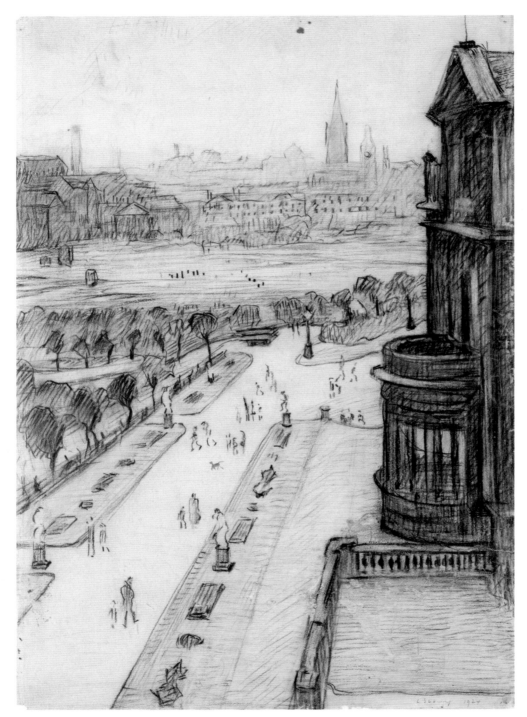

A View from the Window of the Royal Technical College, Salford, looking towards Manchester, 1924
Black chalk and pencil on paper, 55.5 x 38 cm (21¾ x 14¾ in)
• The Lowry, Salford

This view includes the back of the Salford Museum and Art Gallery, the terrace of Peel Park, factories along the River Irwell and St Simon's Church, all images which would reappear in later works.

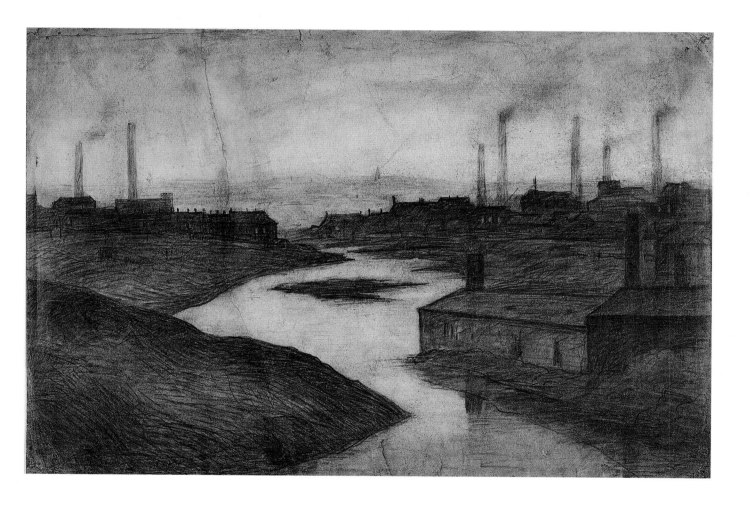

The River Irwell at the Adelphi, 1924
Pencil on paper, 35.5 x 52.3 cm (14 x 20⅝ in) • The Lowry, Salford

Lowry was fascinated by the links between water and industry, and often made use of this theme in his works. The River Irwell flows through Salford and creates a loop close to Peel Park.

Wet Earth Colliery, Dixon Fold, 1924
Pencil on paper, 24.3 x 34.5 cm (9½ x 13½ in) • The Lowry, Salford

Lowry was always interested in the relationship between town and country. He made two drawings and a pastel of the colliery, which closed in 1928, and these are the only complete records that survive.

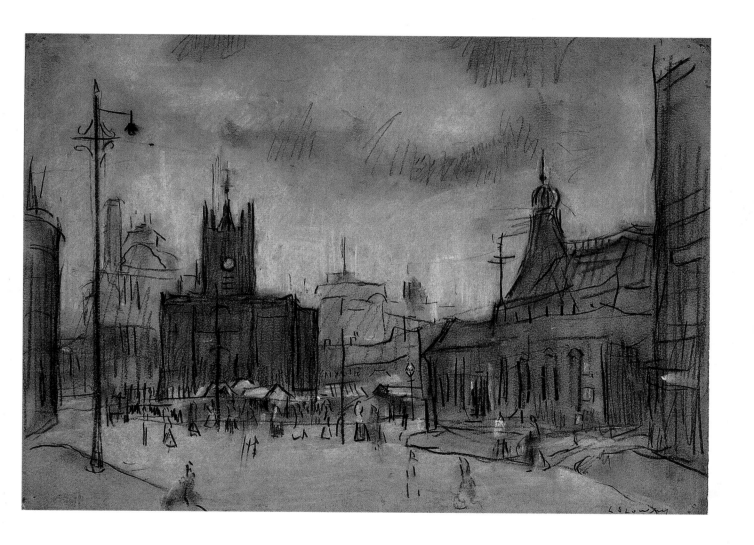

The Flat Iron Market, *c.* **1925**
Charcoal, pencil and white chalk on grey paper,
28.3 x 38.3 cm (11 x 15 in) • The Lowry, Salford

The market, which closed in 1939, was so called because the land it occupied was of triangular shape. The figures in the foreground are created with impressionistic strokes.

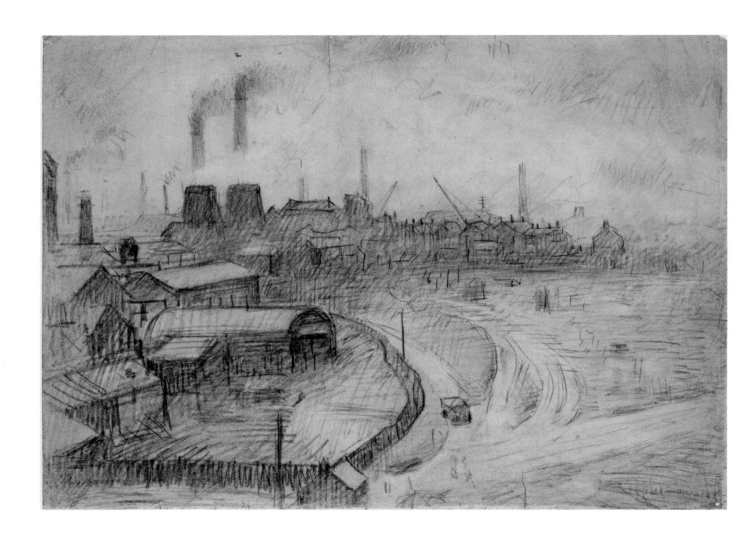

**View from the Window of the Royal Technical College,
Salford, looking towards Broughton, 1925**
Pencil on paper, 26.5 x 36.5 cm (10½ x 14½ in) • The Lowry, Salford

A view looking in another direction from the college. This orientation reveals at close hand more industrial suburbs and evokes the grimy, polluted atmosphere of the area.

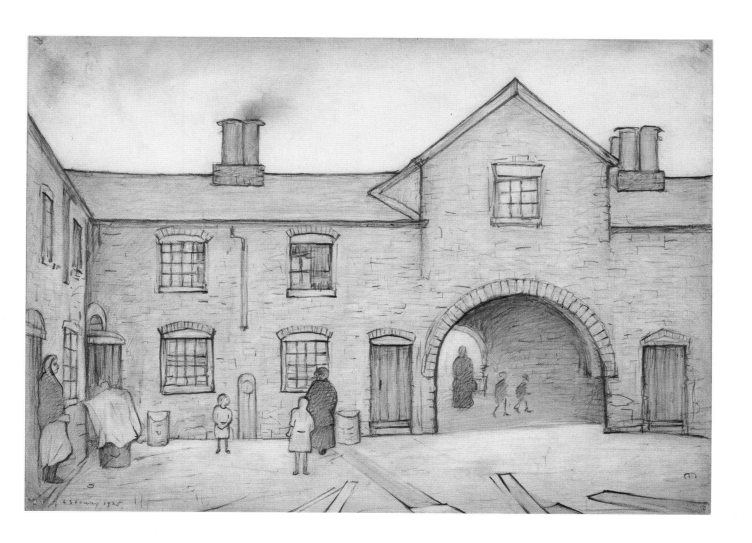

Old Houses, Flint, 1925
Pencil on paper, 25.6 x 35.8 cm (10 x 14 in) • The Lowry, Salford

Lowry enjoyed travelling around Britain. Here, in Flint, he brings out the character of the old houses, drawn with bold lines and great clarity, which seem to radiate their own personality.

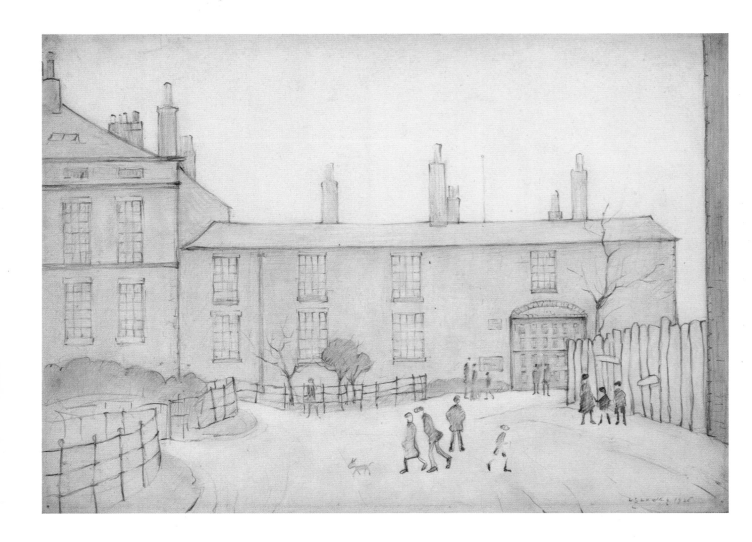

Behind Leaf Square, 1925
Pencil on paper, 24.5 x 34.8 cm (9¾ x 13¾ in) • The Lowry, Salford

Leaf Square was a very fine Georgian area of Salford, which was demolished in the early 1960s. Lowry drew a number of representations of this area, expanding his architectural capabilities.

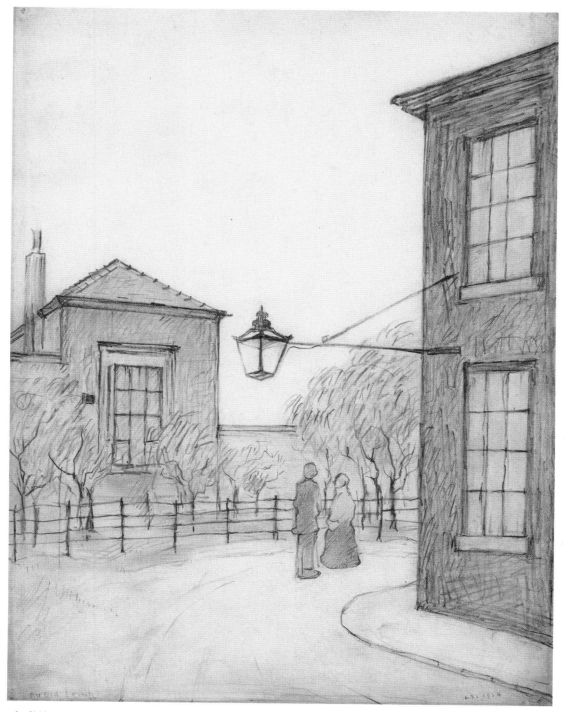

An Old Lamp: Behind Leaf Square, 1926
Pencil on paper, 35.3 x 26.1 cm (14 x 9¼ in) • The Lowry, Salford

The elegant Leaf Square area is dominated here by the attractive street lamp. Such lamps are objects of style with pleasing shape and form, and feature frequently in Lowry's works.

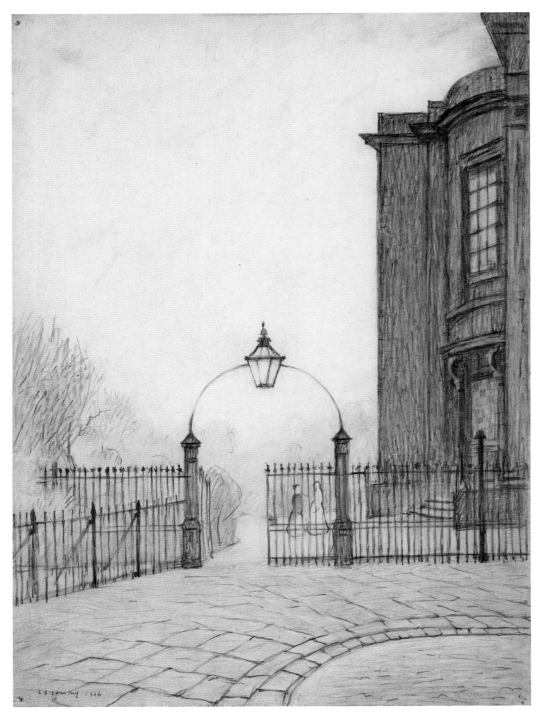

By Christ Church, Salford, 1926
Pencil on paper, 35.5 x 25.3 cm (14 x 10 in) • The Lowry, Salford

The balance and elegance of this view is created by the curve of the pavement reflected in the curve of the arch, and juxtaposed against the straight lines of the fencing.

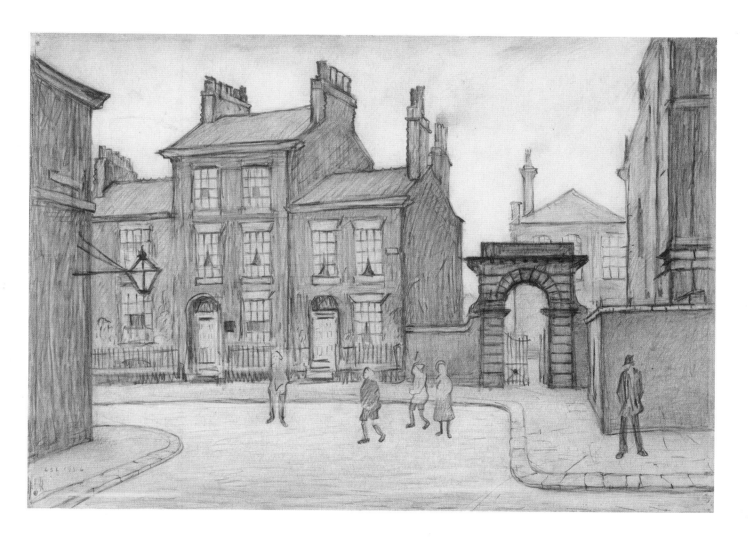

By the County Court, Salford, 1926
Pencil on paper, 24.6 x 34.9 cm (9¾ x 13¾ in) • The Lowry, Salford

A work accurately depicting the bold and confident buildings that represent the rule of law in the city. Lowry's topographical works are important for documenting the north-west between the wars.

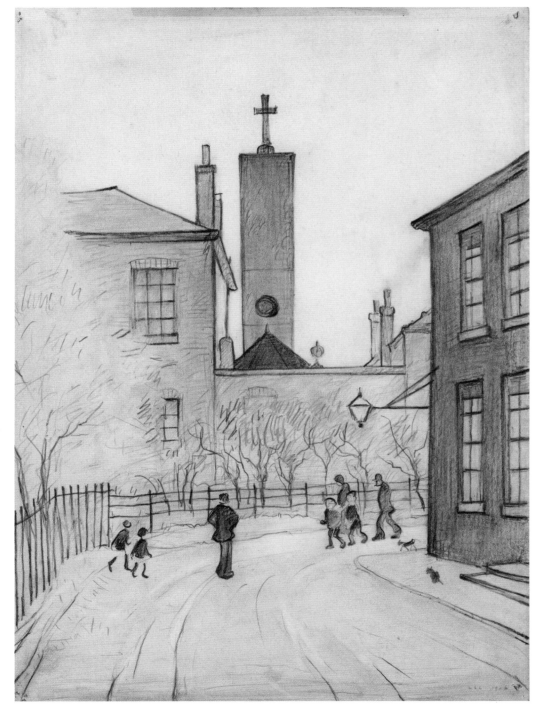

The Tower, 1926

Pencil on paper, 35.5 x 25.3 cm (14 x 10 in) • The Lowry, Salford

This is another depiction of Leaf Square to which Lowry has added an imaginary church tower. Many of Lowry's works are composite scenes in which he combined various elements to create effect.

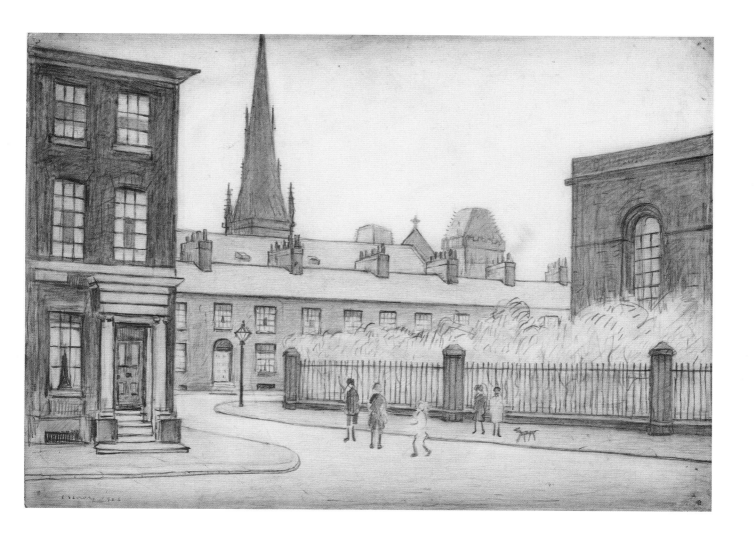

By St Philips Church, Salford, 1926
Pencil on paper, 25.2 x 35.5 cm (10 x 14 in) • The Lowry, Salford

An example of Lowry's topographical scenes where he accurately documented buildings and their surroundings. Lowry's varied use of his pencil creates a multitude of subtle contrasting effects.

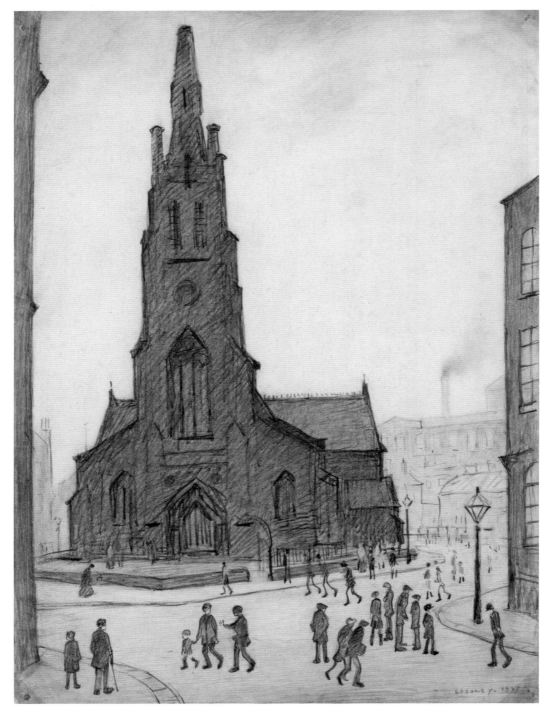

A Street Scene (St Simon's Church), 1927
Pencil on paper, 38.4 x 29.3 cm (15 x 11½ in) • The Lowry, Salford

Lowry drew this scene at the suggestion of his father who told him that the church was soon to be demolished. A month later Lowry returned to the site and the church had gone.

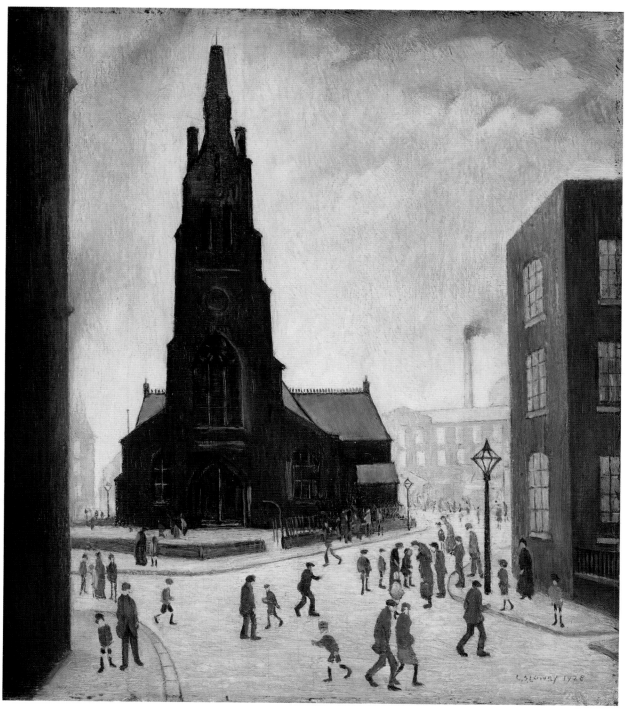

A Street Scene (St Simon's Church), 1928
Oil on board, 43.8 x 38 cm (17¼ x 15 in) • The Lowry, Salford

Lowry worked up his drawing of the church into a painting. It was the first of his pictures bought by the Salford Museum and Art Gallery.

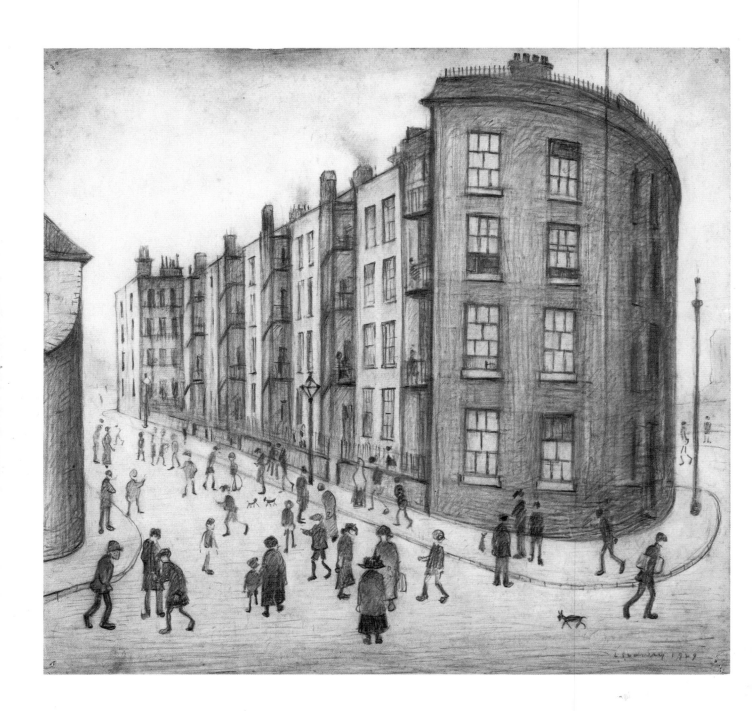

Oldfield Road Dwellings, 1929
Pencil on paper, 41.2 x 43.8 cm (16⅛ x 17¼ in) • The Lowry, Salford

This is a view of workers' flats that curve around a corner in a striking and attractive fashion. Lowry made two drawings and an oil painting of this site.

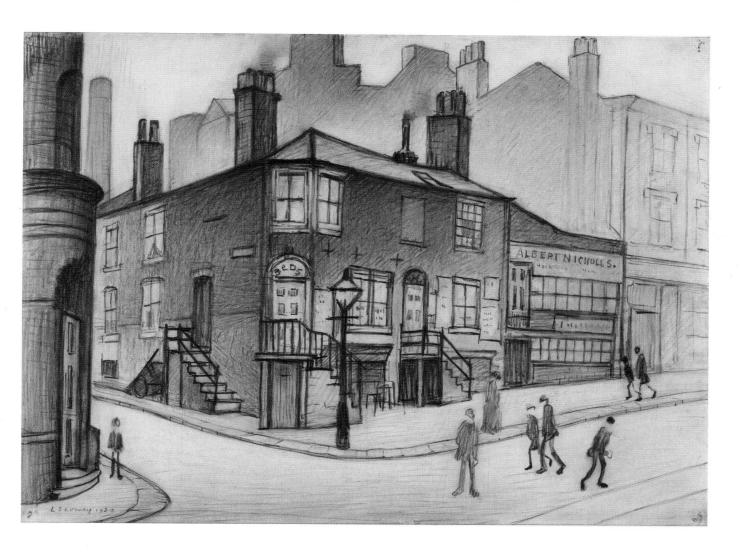

Great Ancoats Street, Manchester, 1930
Pencil on paper, 28 x 38.4 cm (11 x 15 in) • The Lowry, Salford

This is a topographical drawing that records the Ancoats area before redevelopment. The perspective and architectural elements are the confident work of someone who has mastered his craft.

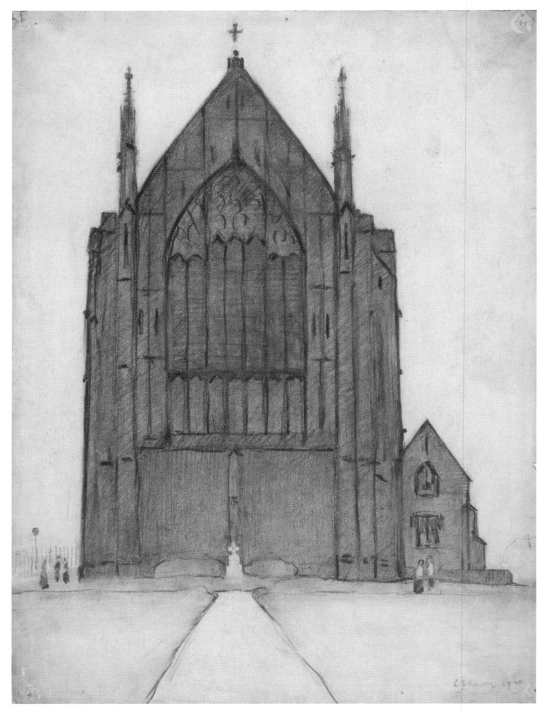

St Augustine's Church, Pendlebury, 1930
Pencil on paper, 35.1 x 26 cm (13¾ x 10¼ in) • The Lowry, Salford

The church is a towering presence dwarfing the people and the white memorial with cross. In Lowry's works, churches are frequently a central image but also appear dark and brooding.

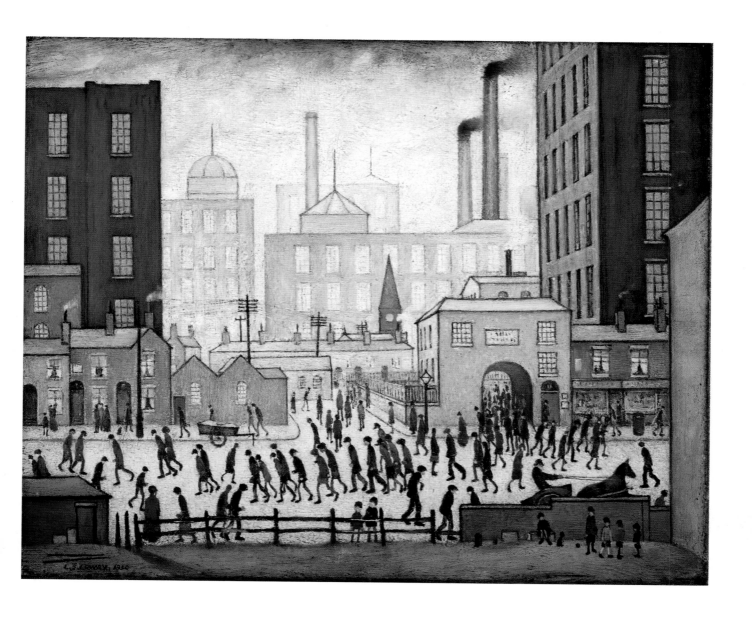

Coming from the Mill, 1930
Oil on canvas, 42 x 52 cm (16½ x 20½ in) • The Lowry, Salford

This oil painting is based on the earlier c. 1917–18 pastel on paper but it is stylistically different, using a white background. Lowry considered this work to be his 'most characteristic mill scene'.

The Lake (detail), 1937
Oil on canvas, 43.4 x 53.5 cm (17 x 21 in) • The Lowry, Salford

One of Lowry's composite works, bringing together various images from different places to create a landscape. Painted in the stressful period before his mother's death, it is a dark and oppressive work evincing despair.

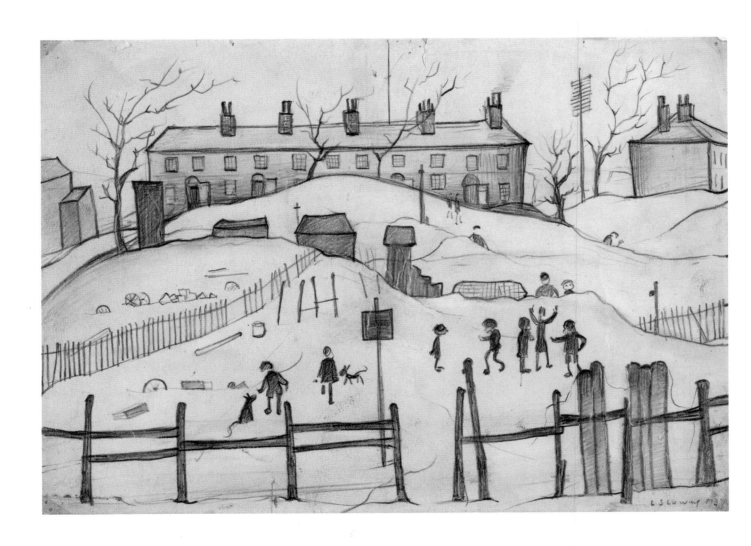

Houses in Broughton, 1937
Pencil on paper, 25.3 x 35.6 (10 x 14 in) • The Lowry, Salford

Here the houses are in the background and the main feature of the work appears to be the children playing happily in the foreground. Lowry met many children on his rent-collecting round.

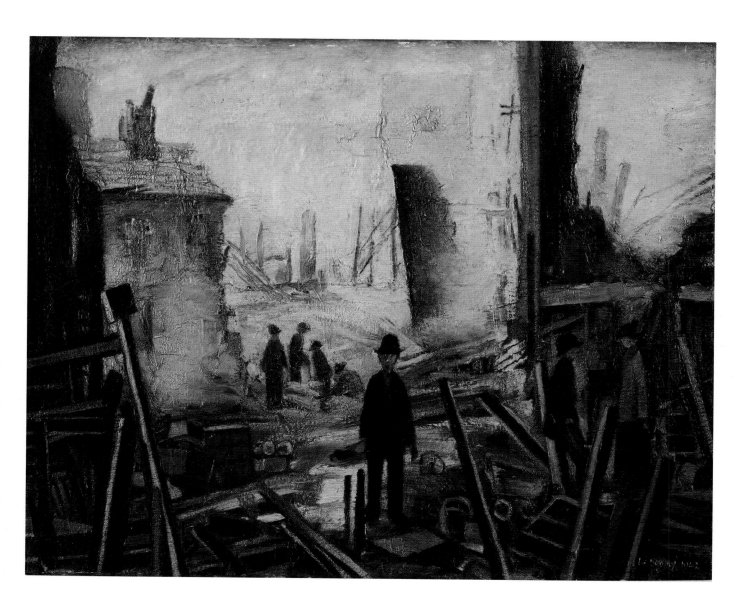

Blitzed Site, 1942
Oil on canvas, 41 x 51 cm (16 x 20 in) • The Lowry, Salford

This is one of Lowry's rare wartime scenes, recording the effects of the Blitz on Manchester. Working as a firewatcher and also as an official War Artist, Lowry surprisingly produced little art related to the war.

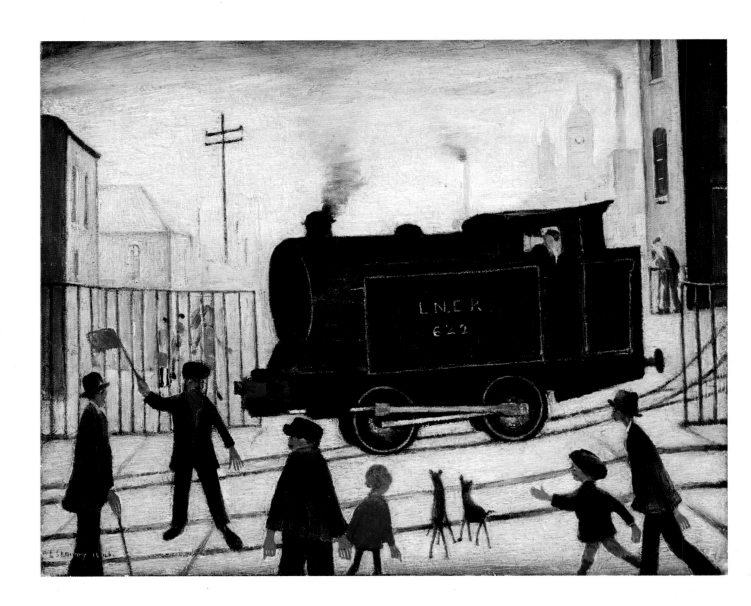

Level Crossing, 1946
Oil on canvas, 46.1 x 56.1 cm (18 x 22 in) • The Lowry, Salford

Lowry produced a number of works based on level crossings after visits to Burton-on-Trent. The dark mass of the train (modelled on a toy train belonging to the son of one of Lowry's friends) projects forward against the white background.

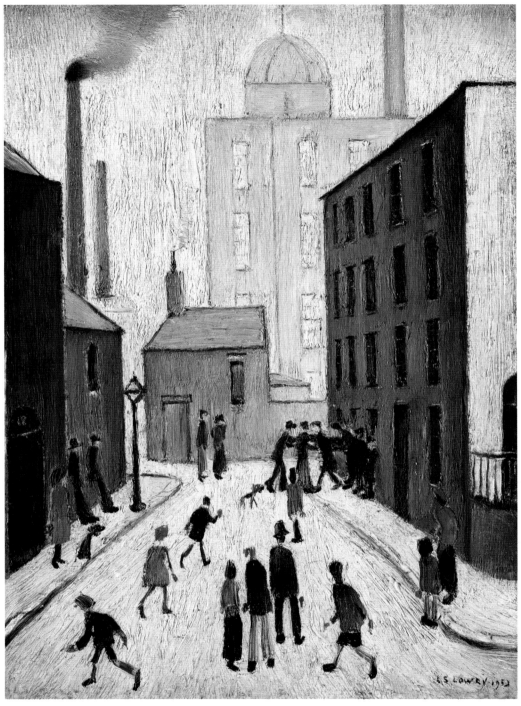

Industrial Scene, 1953

• Norwich Castle Museum & Art Gallery, Norwich

The high buildings accompanied by the tall smoking tower create a feeling of claustrophobia but the white background and the people purposefully coming and going lighten the atmosphere.

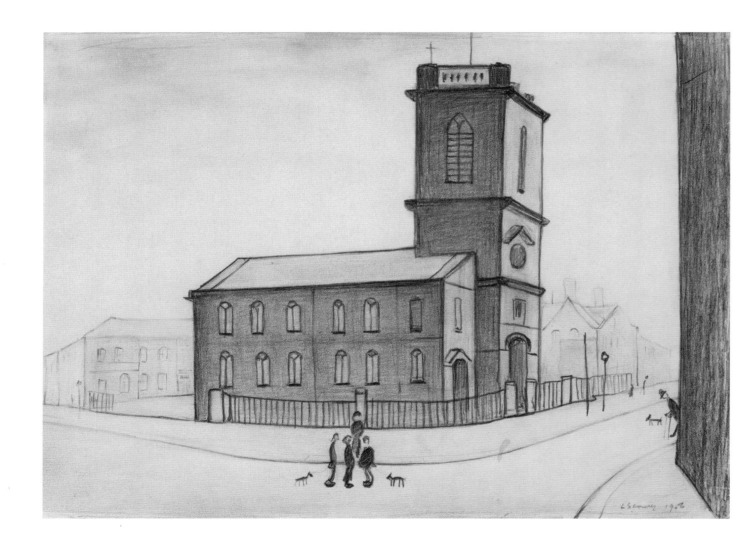

St Stephen's Church, Salford, 1956
Pencil on paper, 24.3 x 35.2 cm (9½ x 14 in) • The Lowry, Salford

In 1956 Lowry was asked to record some buildings before demolition. He endows this church with bold personality and juxtaposes humorous figures in the foreground.

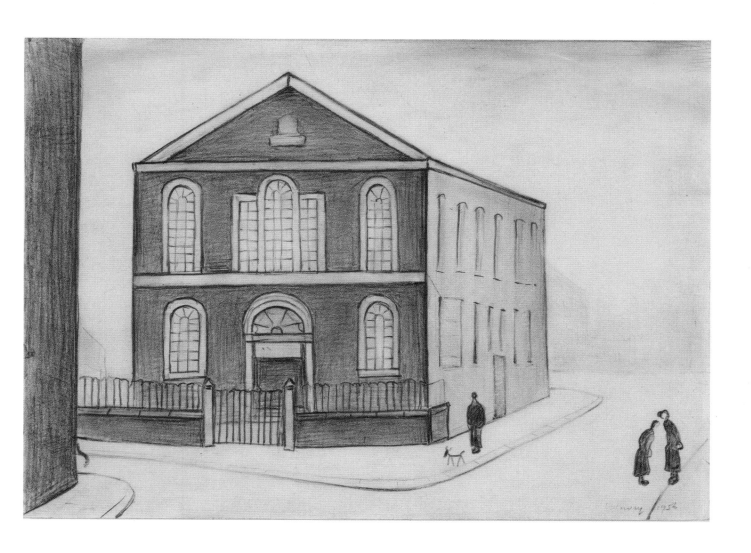

Chapel, St Stephen's Church, Salford, 1956
Pencil on paper, 24.3 x 33.9 cm (9½ x 13½ in) • The Lowry, Salford

Lowry contrasts the grandeur of the dignified and imposing chapel with the everyday figures in the street.
We can just see the leg of someone disappearing around the corner at bottom left.

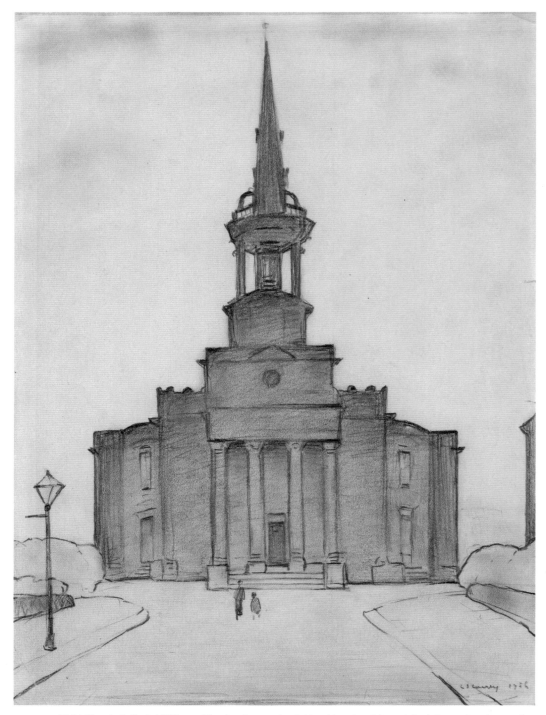

Christ Church, Salford, 1956
Pencil on paper, 33 x 23.7 cm (13 x 9¼ in) • The Lowry, Salford

The church presents a bold and towering statement, its dark mass looming over the people below who appear miniscule by comparison. The church was demolished in 1958.

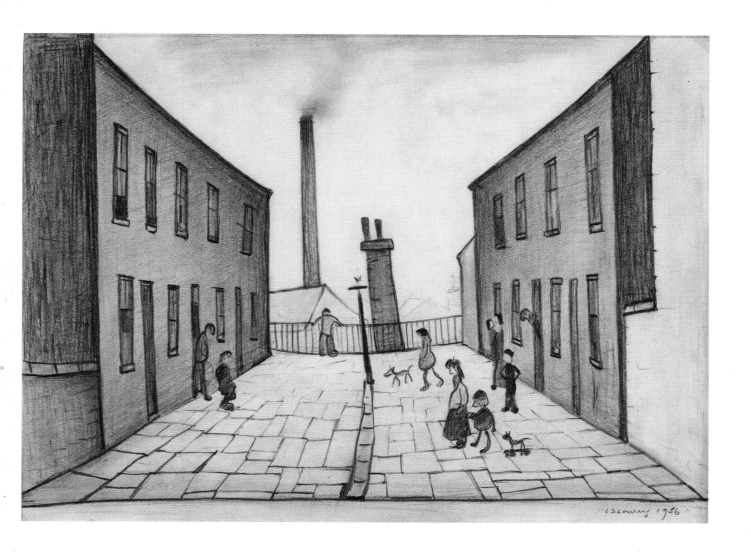

Francis Terrace, Salford, 1956
Pencil on paper, 25.3 x 34.9 cm (10 x 13¾ in) • The Lowry, Salford

Francis Terrace shows an example of workers' 'two-up, two-down' houses near industrial sites.
This created a tight-knit community with people, buildings and dogs all in close proximity.

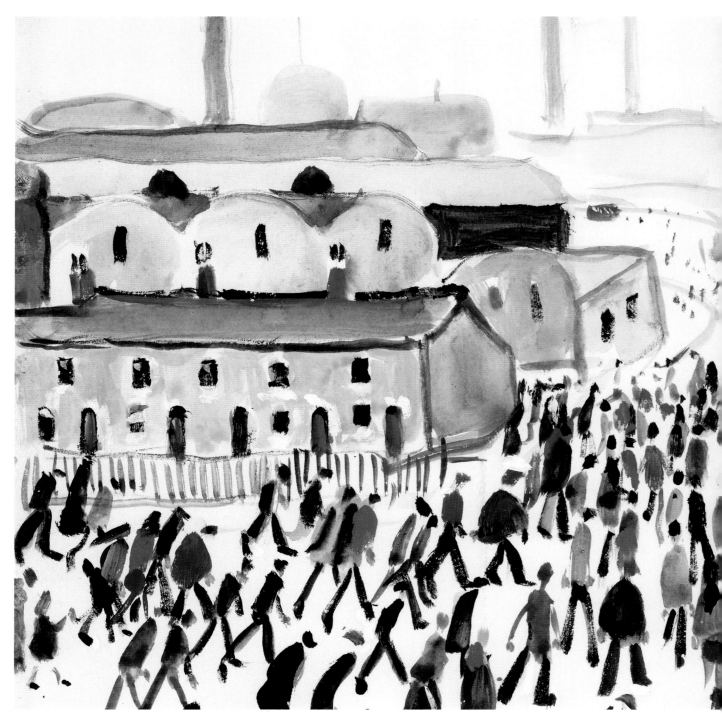

Going to Work (detail), 1959
Watercolour on paper, 27 x 38.5 cm (10¾ x 15 in) • The Lowry, Salford

This is an example of one of Lowry's famous crowd scenes. The colour palette is unusually light and airy with pink and gold-tinged buildings lifting the atmosphere.

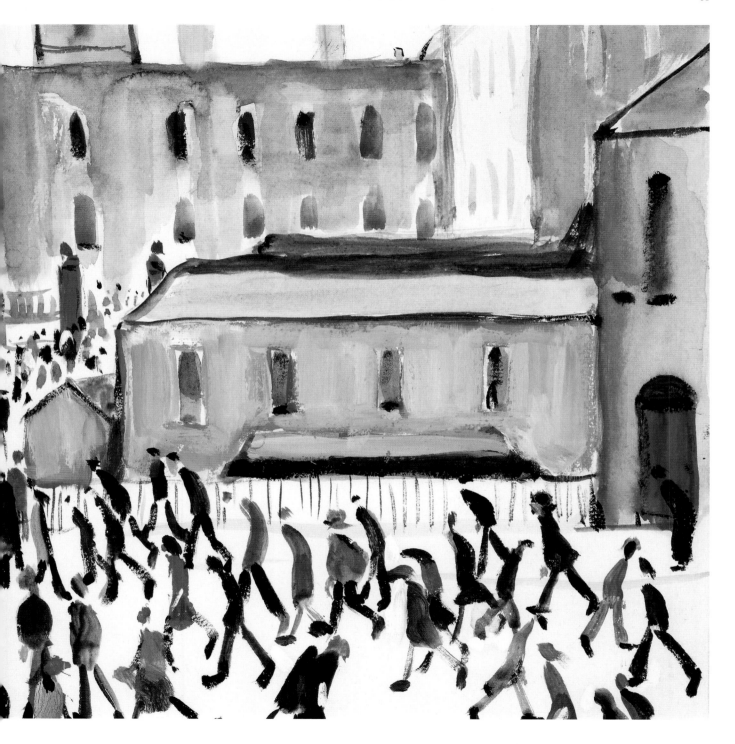

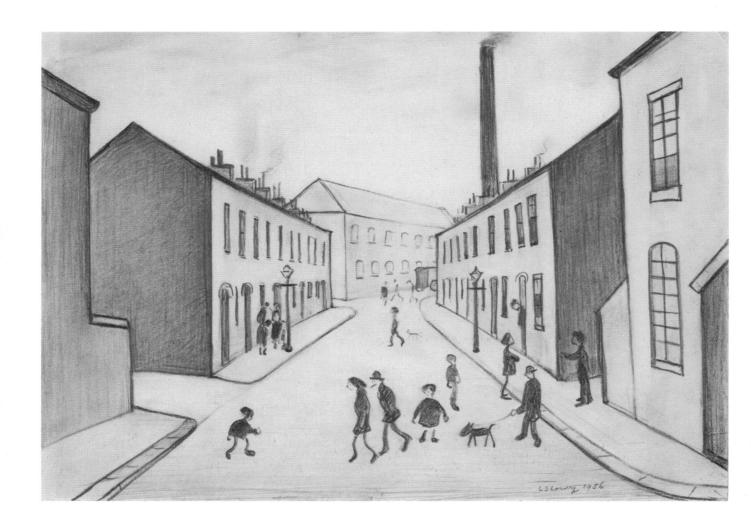

North James Henry Street, Salford, 1956
Pencil on paper, 24.4 x 33.7 cm (9½ x 13¼ in) • The Lowry, Salford

In this scene there is a feeling of space and light, with the figures prominently placed and so attracting the viewer's attention. Unusually, the buildings seem to take second place.

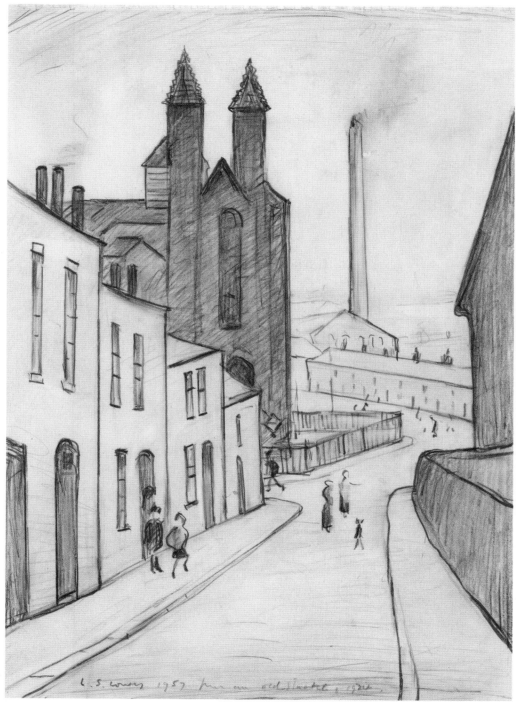

Richmond Hill, 1957

Pencil on paper, 34.6 x 24.4 cm (13¾ x 9¾ in) • The Lowry, Salford

This view looking down the hill effectively recreates the steep descent, ending with the ubiquitous mill tower at the bottom of the street.

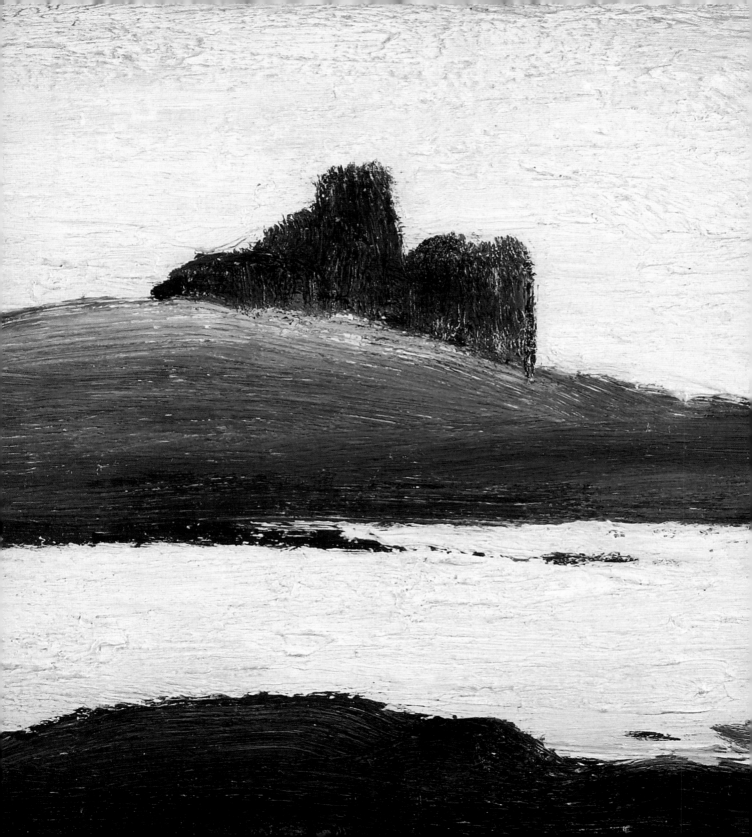

Landscapes

Lowry was an accomplished

artist of nature, whether in

the town park or in the

wider countryside.

L.S. LOWRY. 1937

Landscape, *c.* 1912
Oil on canvas, 33.5 x 23.5 cm (13¼ x 9¼ in) • The Lowry, Salford

This early work by Lowry clearly shows the influence of the Impressionists with its blurred effects and atmospheric rendering. One of Lowry's early teachers was the Impressionist Adolphe Valette.

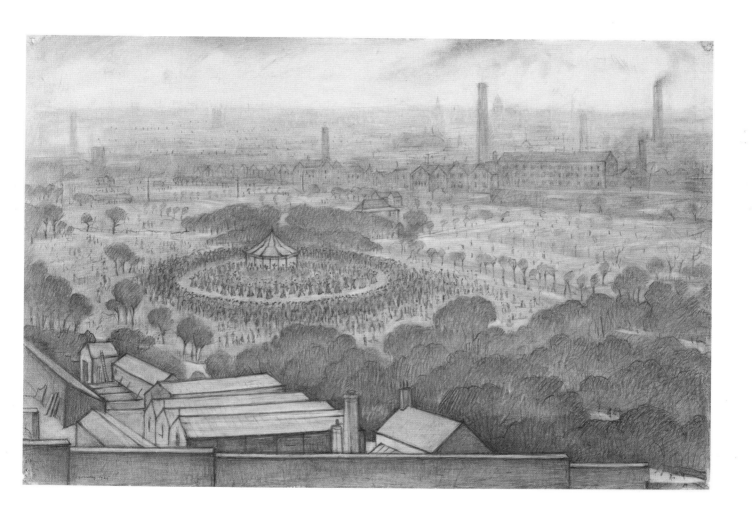

Bandstand, Peel Park, Salford, 1925
Pencil on paper, 36.7 x 54.6 cm (14½ x 21½ in) • The Lowry, Salford

In the 1920s the bandstand was a popular feature of community gatherings. For a brief time people enjoyed music in the park and escaped from the industrial areas shown in the background of this view.

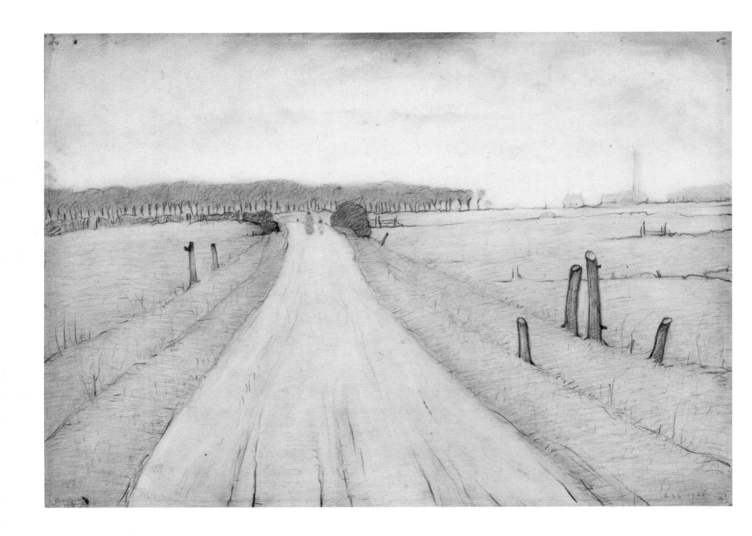

Country Road, 1925
Pencil on paper, 24.5 x 34.7 cm (9¾ x 13¾ in) • The Lowry, Salford

Lowry drew many country landscape scenes in the 1920s, this one being a view near Lytham St Anne's. Such work led to him being asked to illustrate the 1931 publication, *A Cotswold Book*.

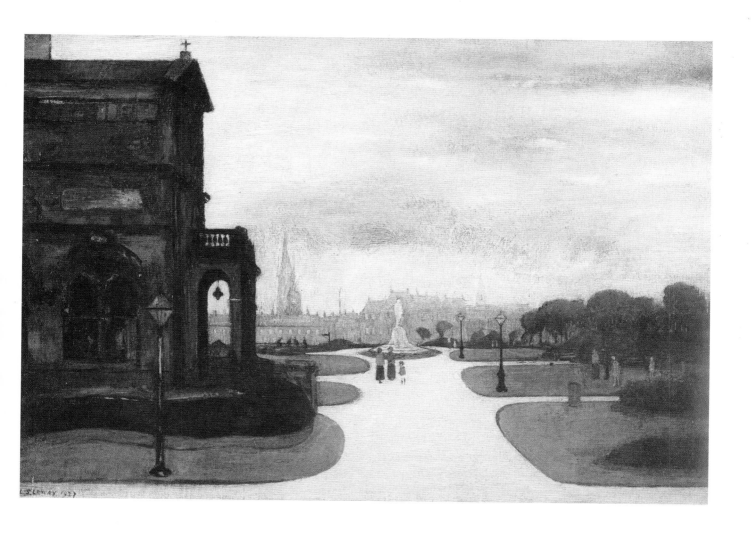

Peel Park, Salford, 1927
Oil on board, 35.5 x 50.5 cm (14 x 20 in) • The Lowry, Salford

This view of Peel Park concentrates on man-made structures rather than nature. It shows a side view of the library entrance and looks over to buildings and church towers in the background.

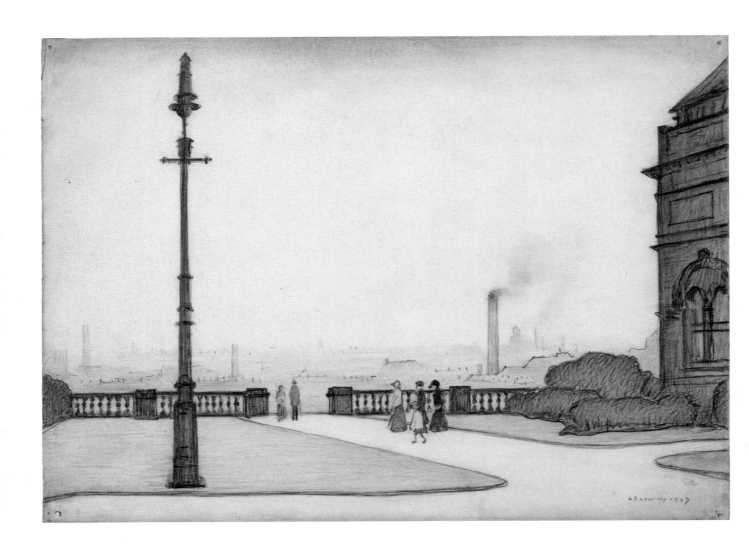

The Terrace, Peel Park, Salford, 1927
Pencil on paper, 26 x 35.8 cm (10¼ x 14 in) • The Lowry, Salford

Lowry said that many of his early drawings were made from this spot. The elegant play of the horizontal balustrades with the vertical lamplight and tower contrast effectively with the delicately hazy background.

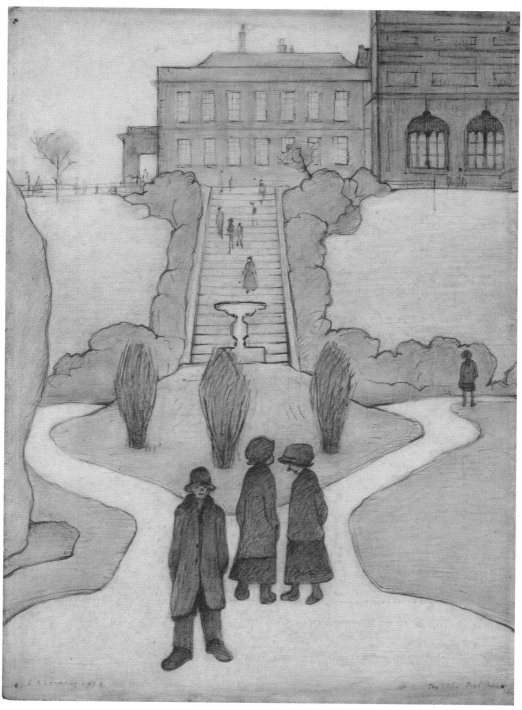

The Steps, Peel Park, Salford, 1930
Pencil on paper, 38.5 x 27 cm (15 x 10¾ in) • The Lowry, Salford

This is a view up to the Salford Museum and Art Gallery; the mansion at the top of the steps was demolished in the 1930s. The man in the foreground looks out disconcertingly at the viewer.

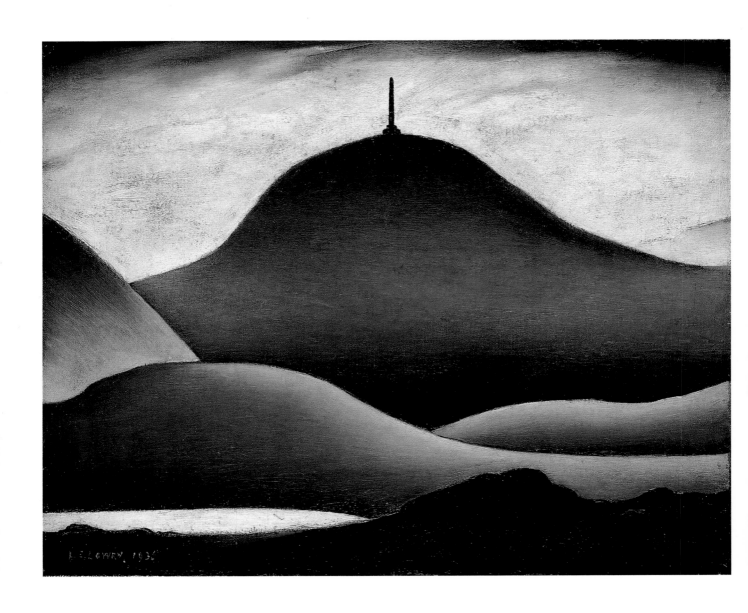

A Landmark, 1936
Oil on canvas, 43.4 x 53.6 cm (17 x 21 in) • The Lowry, Salford

One of the so-called 'lonely landscapes' of the 1930s, which seem to depict the artist's inner despair as much as the desolation of the countryside.

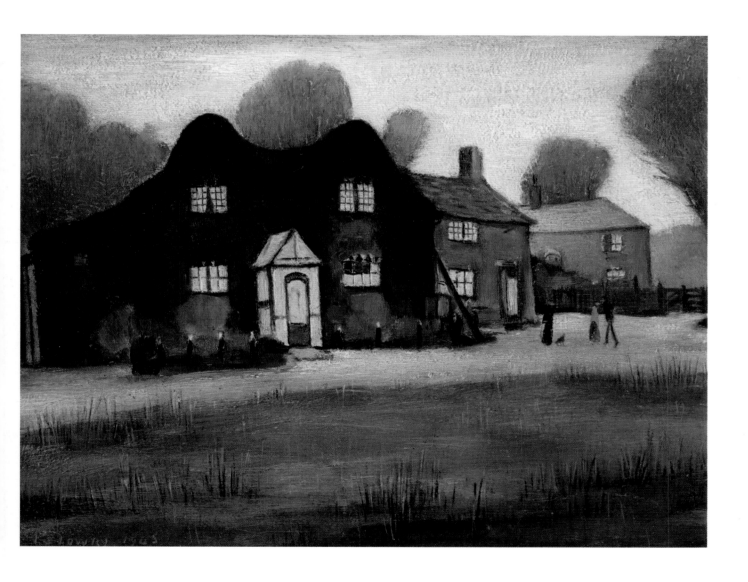

An Old Farm, 1943
Oil on board, 28.5 x 37.9 cm (11¼ x 15 in) • The Lowry, Salford

Lowry drew and painted a number of studies of individual houses. He seemed to have been interested in capturing the individual personality and character of each one.

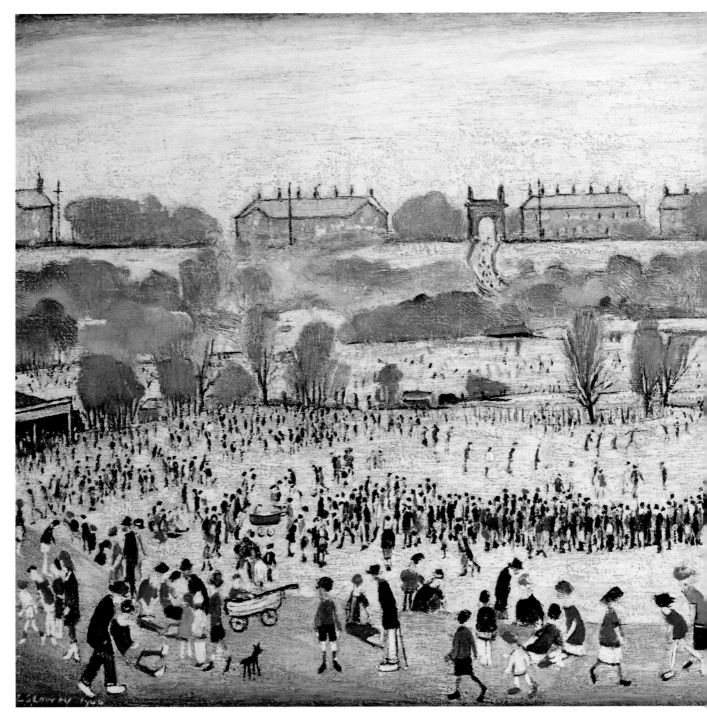

Peel Park, Salford, 1944
• Private Collection

A bright and cheerful depiction of the ever-loved Peel Park. Its symbolic role as a place to be close to nature, free from the tyranny of the industrial arena, is captured in this endearing work.

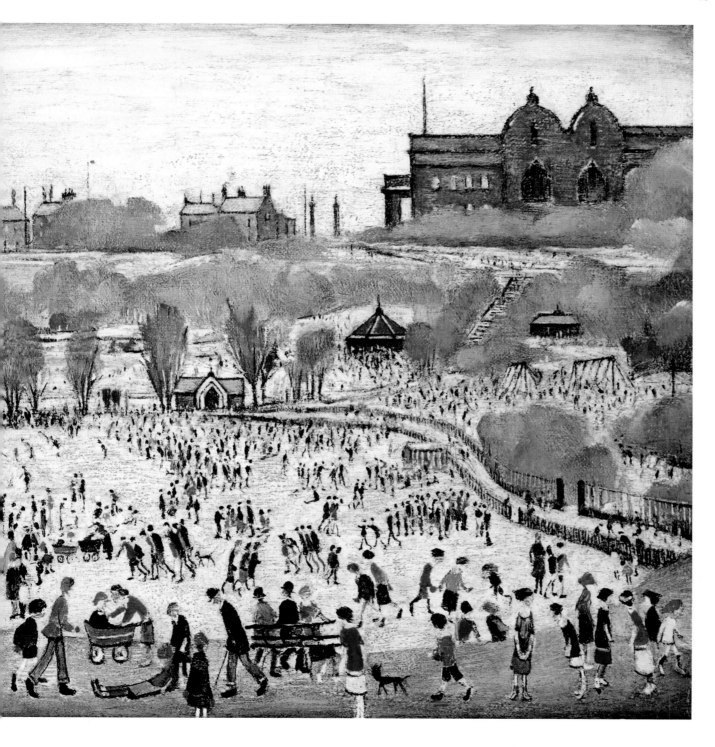

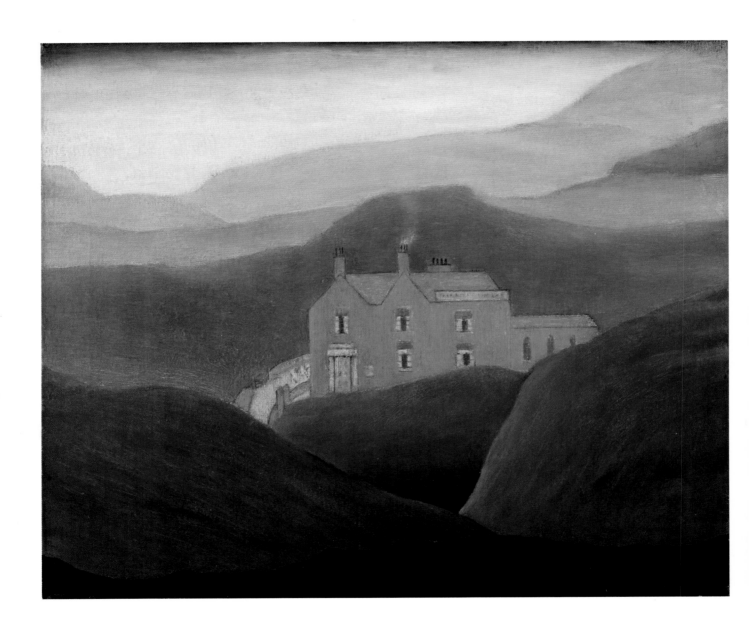

House on the Moor, 1950
Oil on canvas, 49 x 59.5 cm (19¼ x 23½ in) • The Lowry, Salford

Another character study of a house, this one is shown with particular reference to its surroundings of moorland hills. Lowy said that this work epitomized the mood of his 'lonely landscapes'

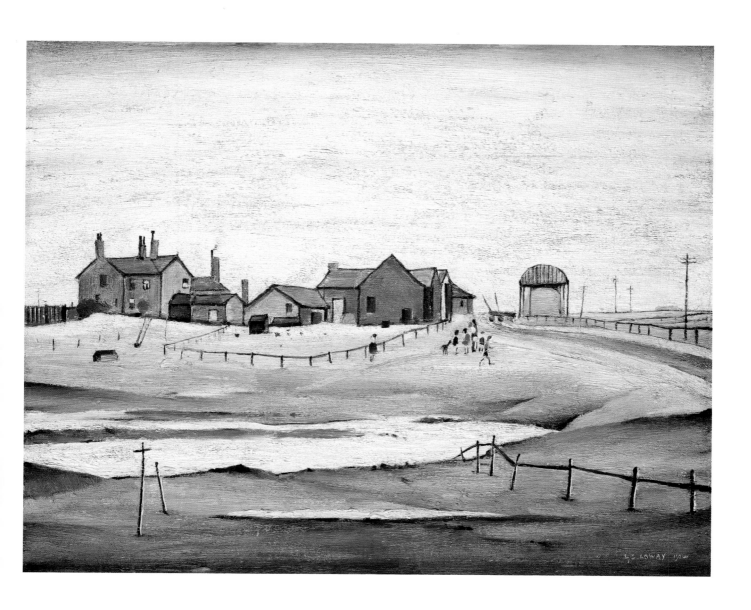

Landscape with Farm Buildings, 1954
• Norwich Castle Museum & Art Gallery, Norwich

A light, bright work filled with open space and a sense of expansion. The warm-coloured buildings gather together in a comforting manner and the water feature in the foreground completes the image.

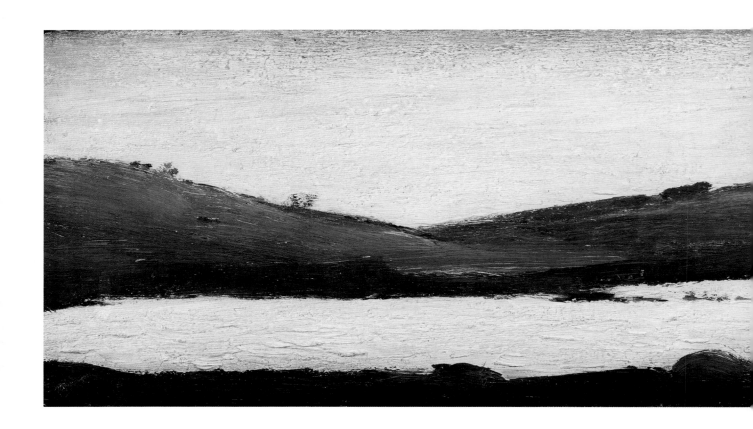

Landscape in Cumberland, 1951
Oil on panel, 15.9 x 58.7 cm (6¼ x 23 in) • The Lowry, Salford

A bare and stark view with one of Lowry's particular interests in the main foreground, a study of a large lake that is counterbalanced by a wide expanse of sky.

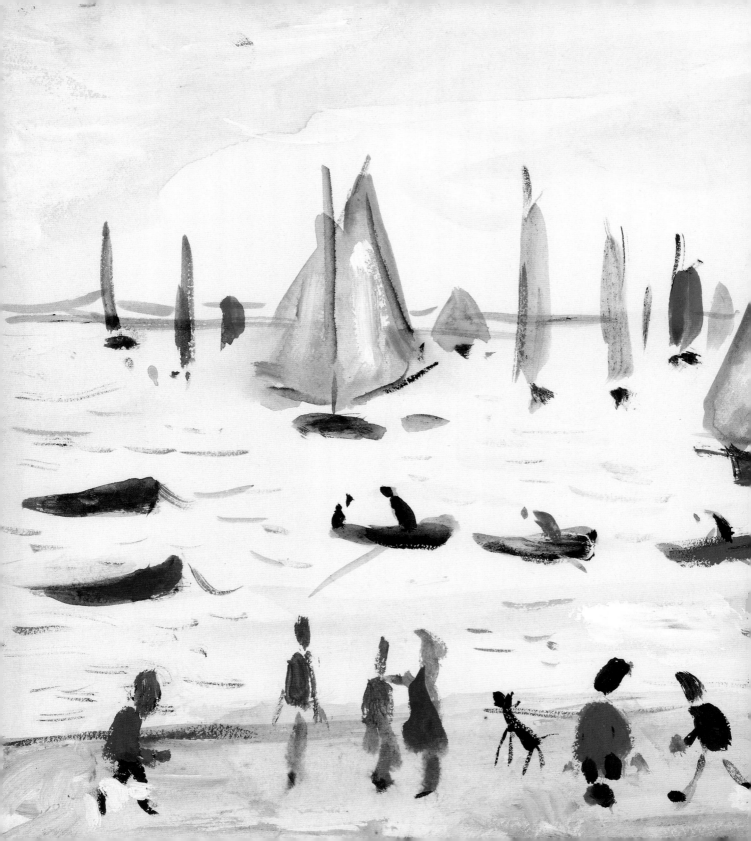

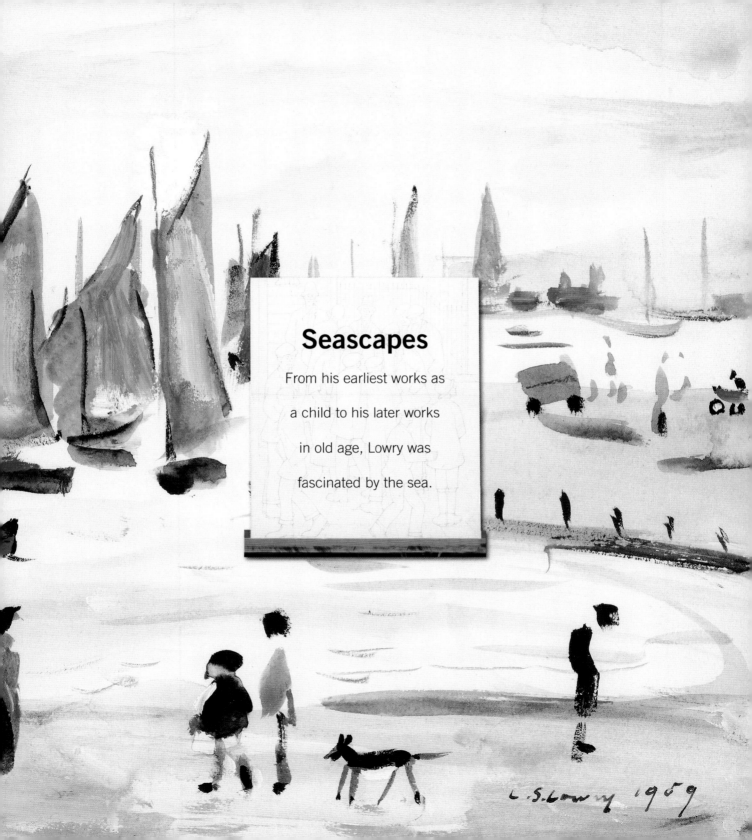

Seascapes

From his earliest works as
a child to his later works
in old age, Lowry was
fascinated by the sea.

L.S.Lowry 1959

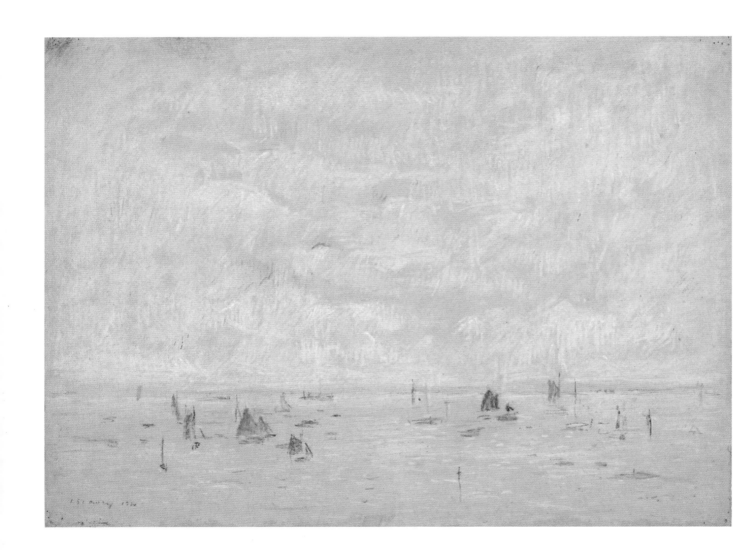

Yachts, 1920
Pastel on paper, 28.4 x 38.2 cm (11 x 15 in) • The Lowry, Salford

This delicate study of a vast sky, merging with the hazy sea scattered with impressionistic representations of yachts, evokes a calm restfulness. Lowry would return time and again to this subject.

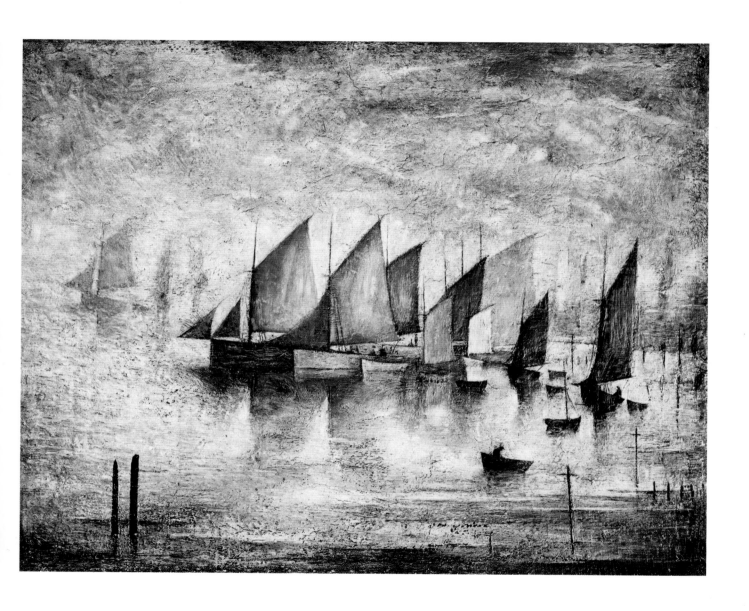

Sailing Boats, 1930
• Private Collection

The boats here are clear and bold but the threatening sky creates a fear and dread of what could happen to them if a storm erupts. The two vertical pieces of black wood at the far left increase this feeling of unease.

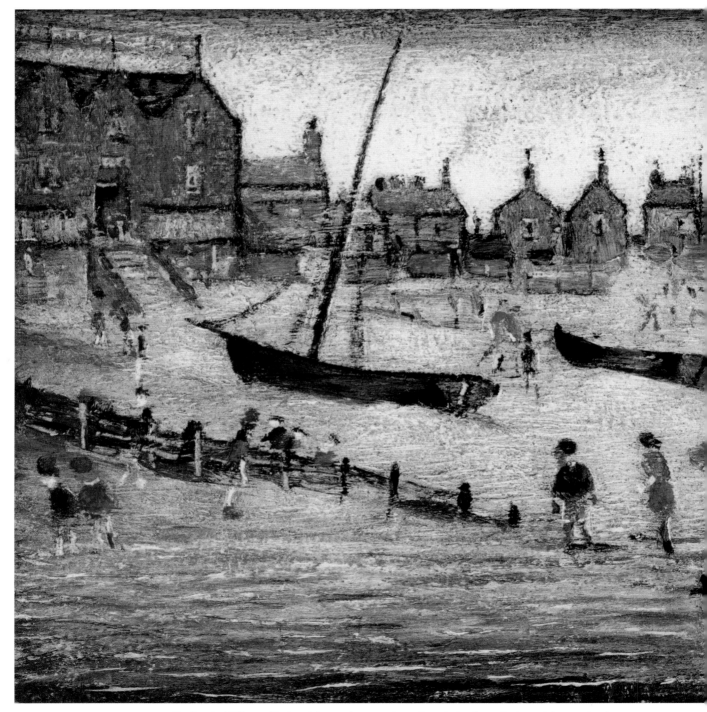

The Beach, 1947
• Private Collection

The beach here conjures up a happy time of relaxation and enjoyment. Lowry enjoyed family holidays on the north-west coast as he was growing up.

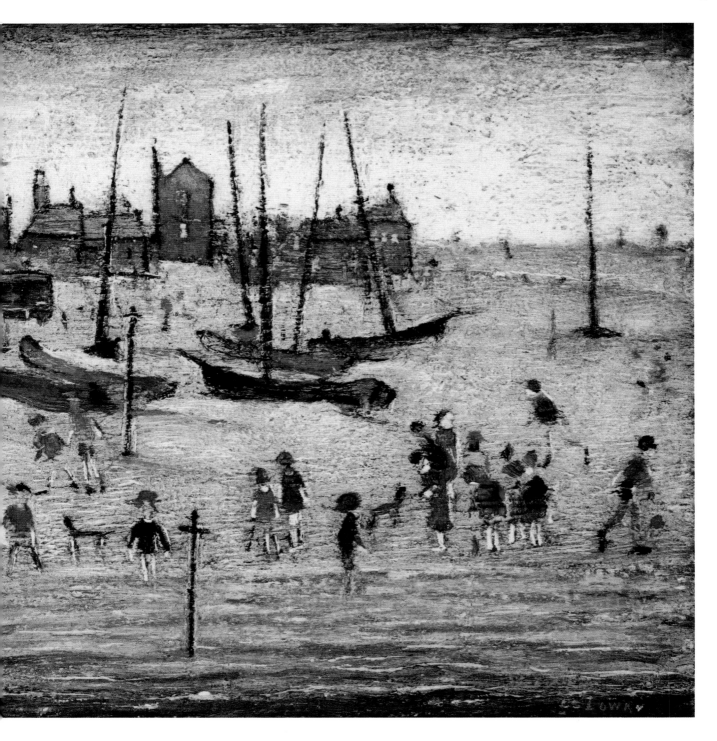

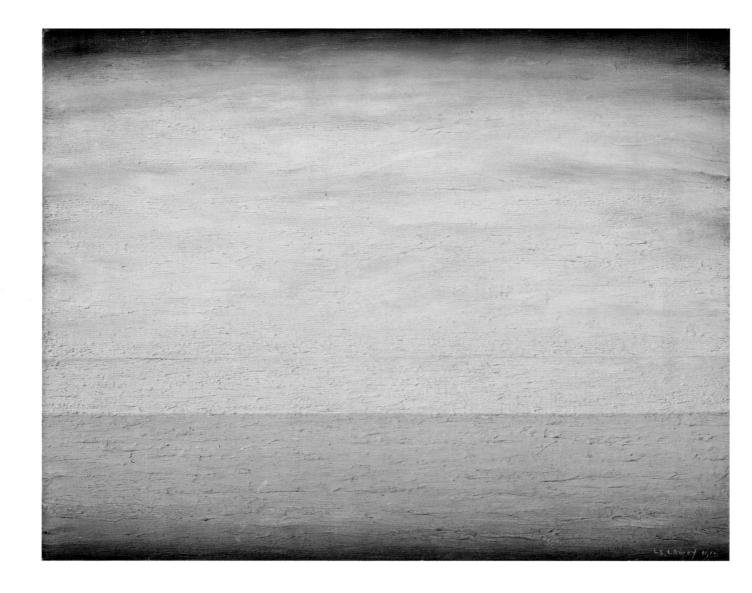

Seascape, 1952
Oil on canvas, 39.5 x 49.3 cm (15½ x 19½ in) • The Lowry, Salford

A peaceful, almost golden, sea and a wide-open sky are framed at top and bottom with intimations of a veiled dark threat. This work initially attracted much criticism but Lowry declared: 'I never expected the picture to be very popular… I think it is one of the best things I've ever done.'

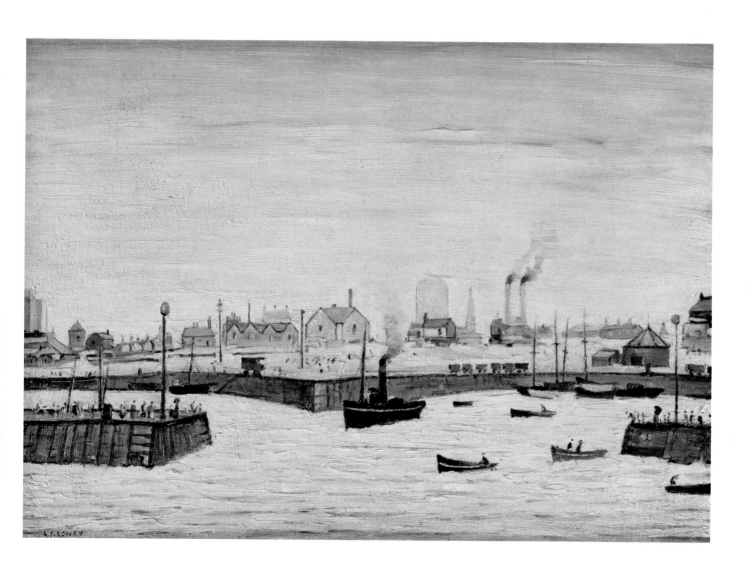

The Harbour (Maryport), 1957
• Private Collection

Lowry painted many pictures of docks and busy harbours, seemingly fascinated by the activity of the boats. Here in the background there are also references to an industrial hinterland with the smoking towers.

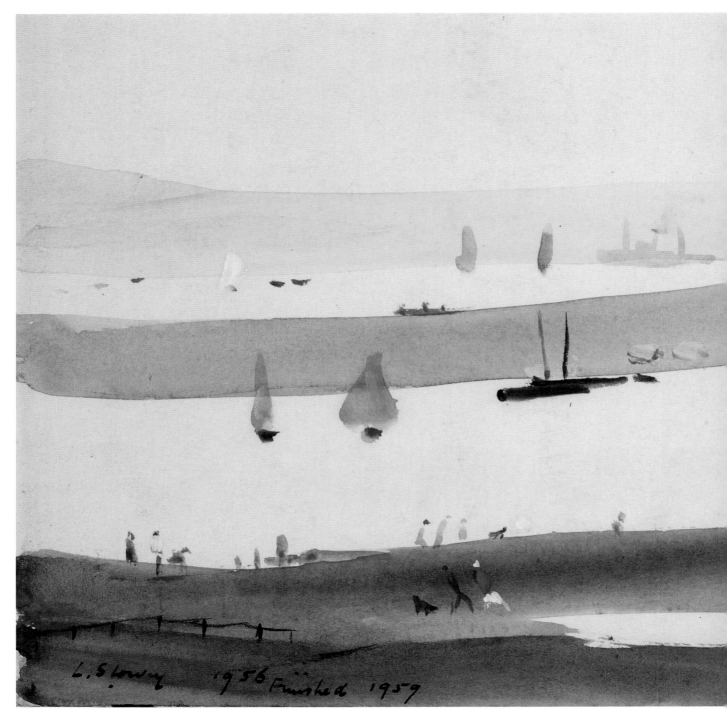

The Estuary, 1956–59
Watercolour on paper, 24 x 34.2 cm (9½ x 13½ in) • The Lowry, Salford

One of the few watercolours produced by Lowry. He recalled that he had done 'no more than a dozen' as it restricted the possibility of making changes because the paint dried so quickly.

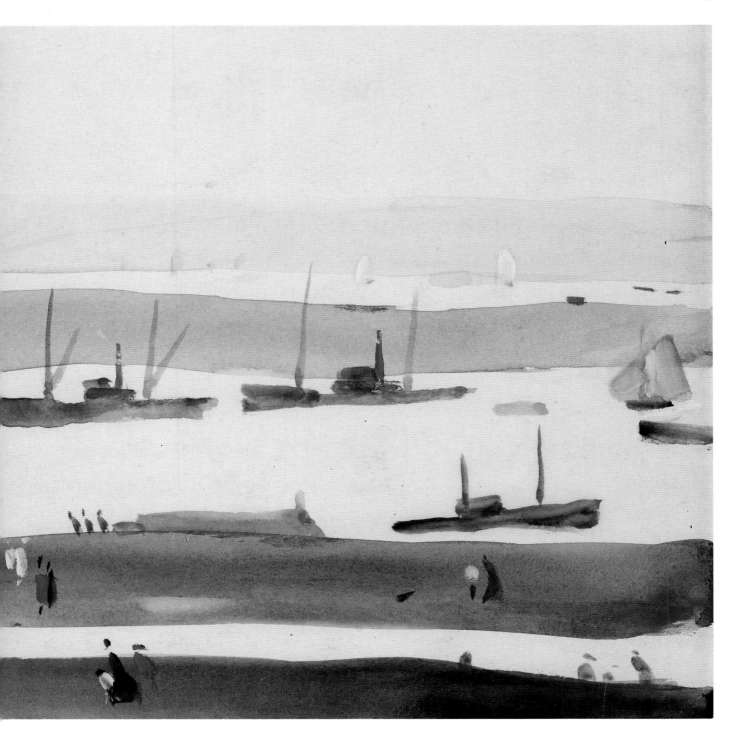

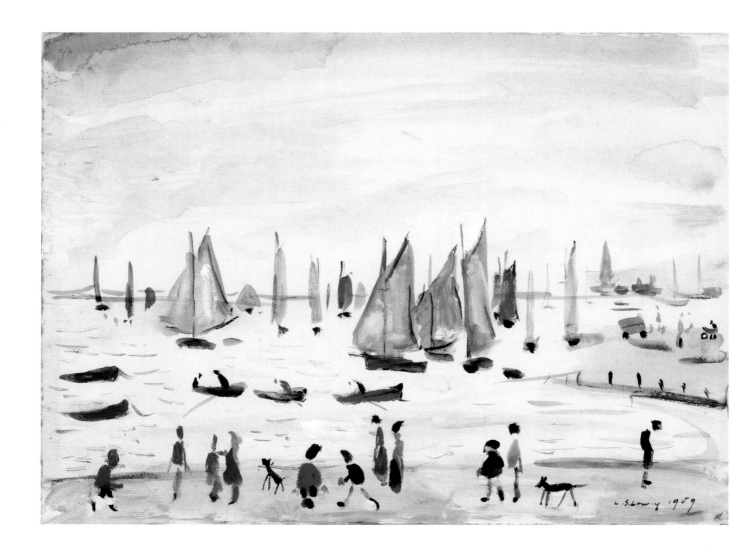

Yachts, 1959
Watercolour on paper, 26 x 36.2 cm (10¼ x 14¼ in)
• The Lowry, Salford

A bright and sunny, almost cheerful work. The sun is shining and people seem to be enjoying themselves. Only the hunched-over figure in black on the right seems dejected; an outsider, perhaps the artist himself?

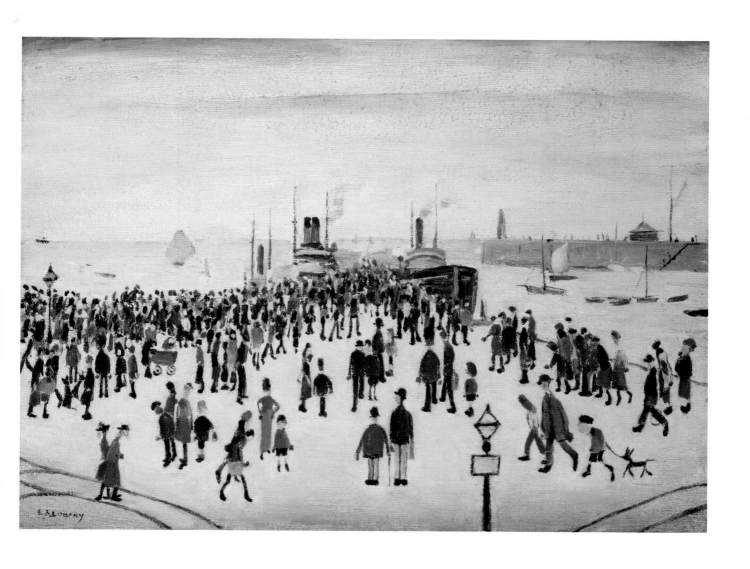

Ferry Boats, 1960
• Private Collection

A light, bright work which captures a sense of excitement as the crowds gather to take the boats to their chosen destination. A sense of hopefulness – unusual for a Lowry work – prevails.

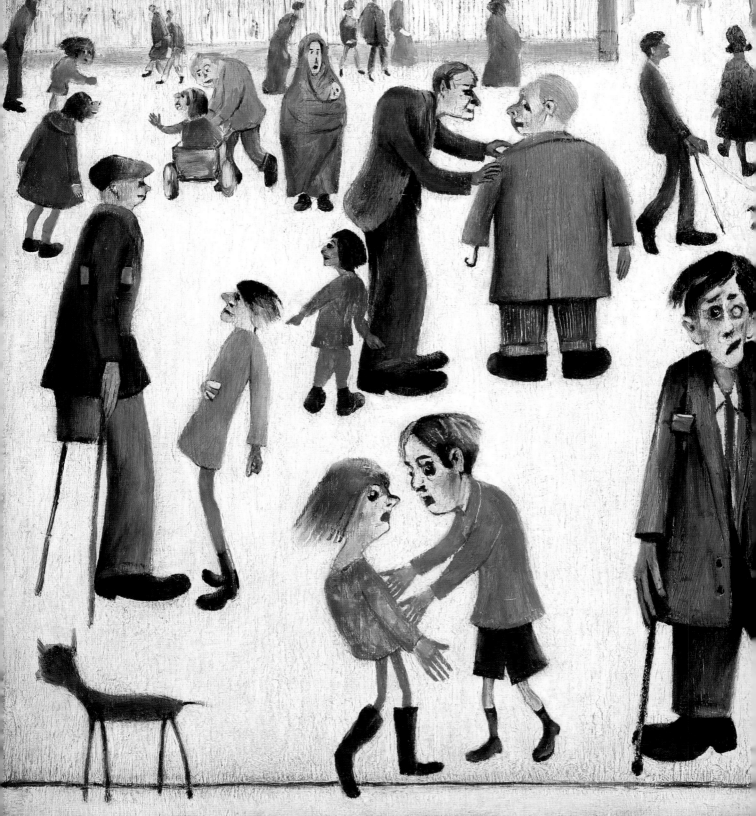

L.S.Lowry 1949

People & Portraits

From academic studies to the peculiarities and oddities of the human race, all types of people populate Lowry's works.

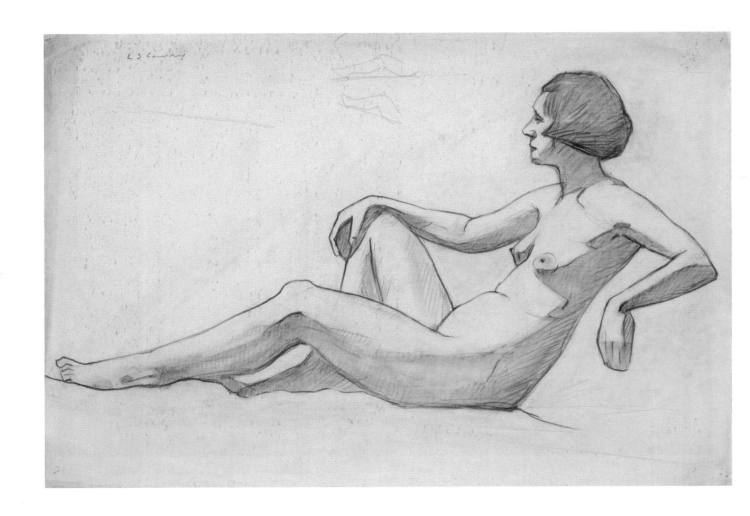

Reclining Nude (Facing Left), *c.* **1906**
Pencil on paper, 35.1 x 52.8 cm (13¾ x 20¾ in) • The Lowry, Salford

One of Lowry's works drawn in the life class at art school. He is here experimenting with dark shading to create effects of contour and light.

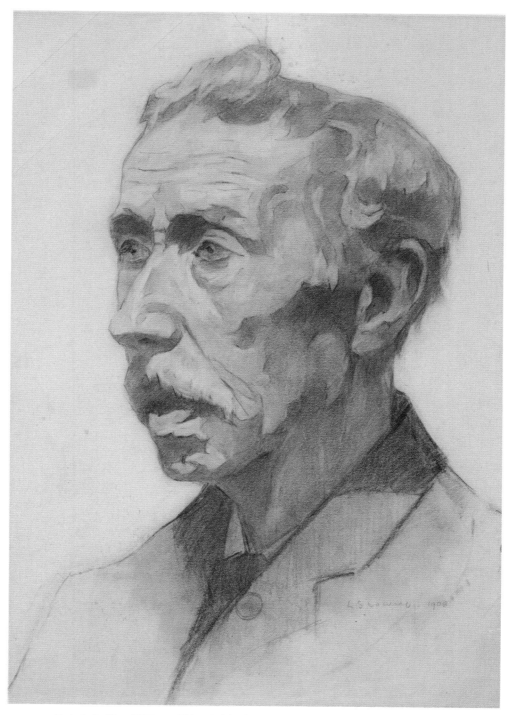

Portrait of a Man, 1908
Pencil on paper, 40.2 x 22.7 cm (15¾ x 9 in) • The Lowry, Salford

This portrait is of Julian Aeronson, one of the life models at Manchester School of Art, who also appears in artwork by Adolphe Valette. Lowry himself said that he considered drawing from life to be 'the foundation of painting'.

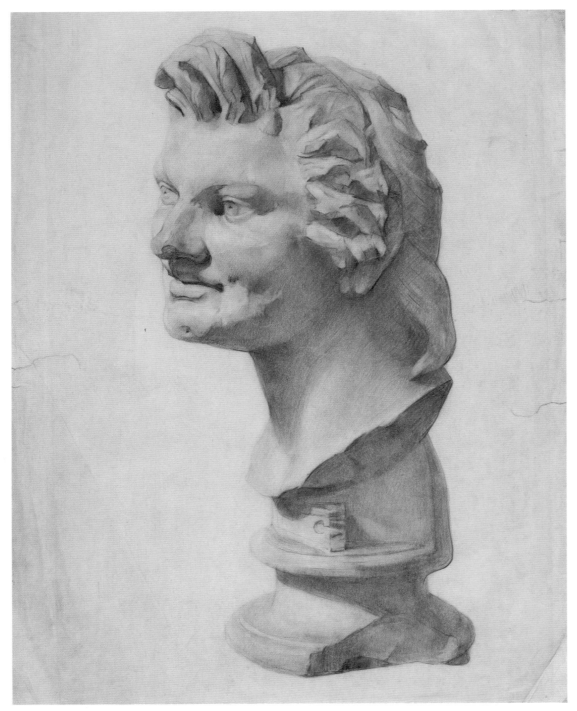

Head From the Antique, *c.* 1908
Pencil on paper, 52 x 33.7 cm (20½ x 13¾ in) • The Lowry, Salford

This study is finely drawn and carefully finished using a variety of pencil techniques. Lowry has noted under his signature that it took 10 hours to produce.

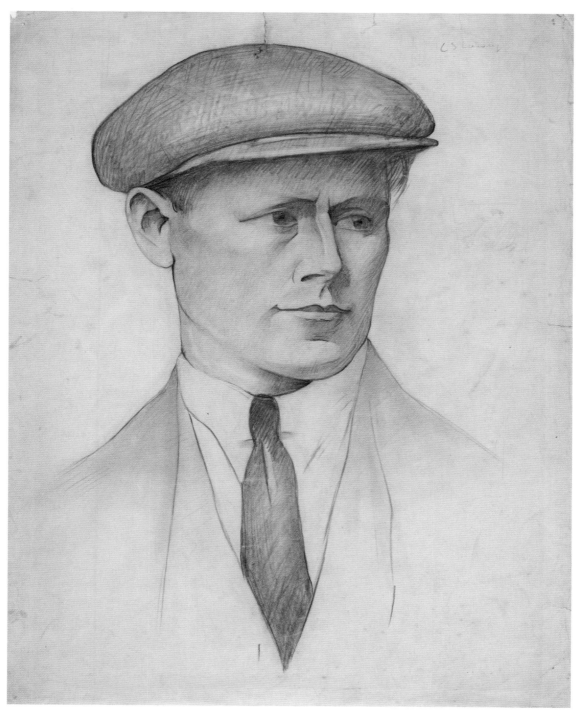

Head of a Young Man in a Cap, *c.* **1912**
Pencil on paper, 45.5 x 33.7 cm (18 x 13¼ in) • The Lowry, Salford

Lowry was renowned for not painting shadows but here he shows that he could create highly effective and sophisticated shadow effects which add depth and quality to the image.

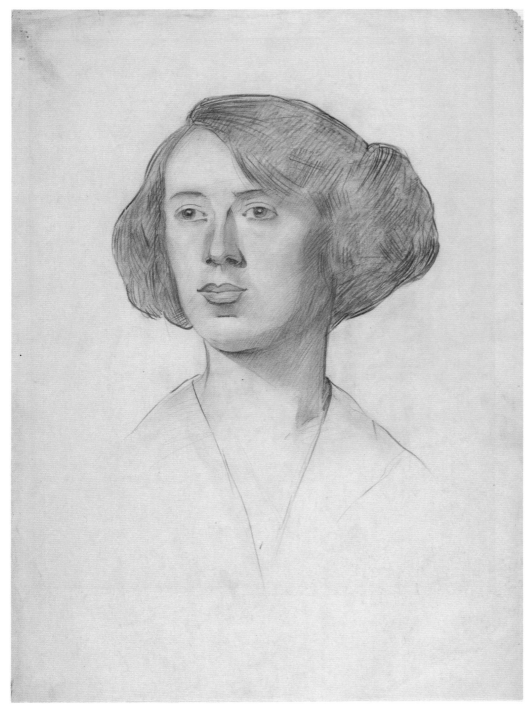

Girl with Bouffant Hair, *c.* **1912**
Pencil on paper, 41.8 x 34.8 cm (16½ x 13¾ in) • The Lowry, Salford

This work conveys a strong sense of the sitter's powerful personality. The use of firm pencil strokes and hatching create the illusion of depth in the bouffant hairstyle.

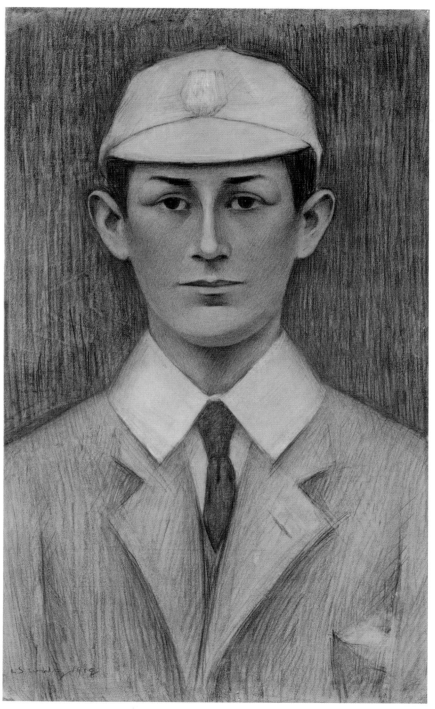

Boy in a School Cap, 1912
Chalk and pencil on paper, 42.5 x 24.5 cm (16¾ x 9¾ in)
• The Lowry, Salford

The dark background of strong vertical pencil strokes creates an unusual backdrop for a Lowry life study. It is thought that this boy was a friend of the family who died in action in the First World War.

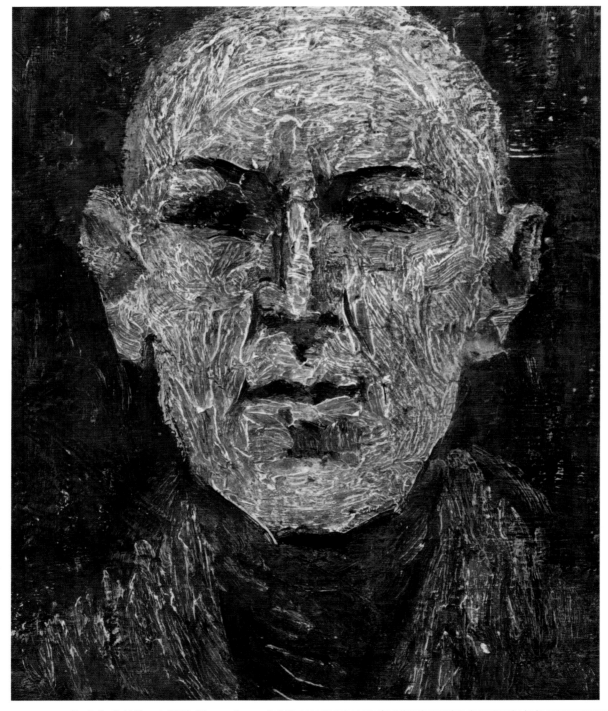

Head of a Bald Man, *c.* **1913–14**
Oil on Board, 37.3 x 26.4 cm (14¾ x 10½ in) • The Lowry, Salford

A somewhat disconcerting close-up of a rather threatening character who looks out uncompromisingly at the viewer. The dark background and dark clothing add to the oppressive atmosphere.

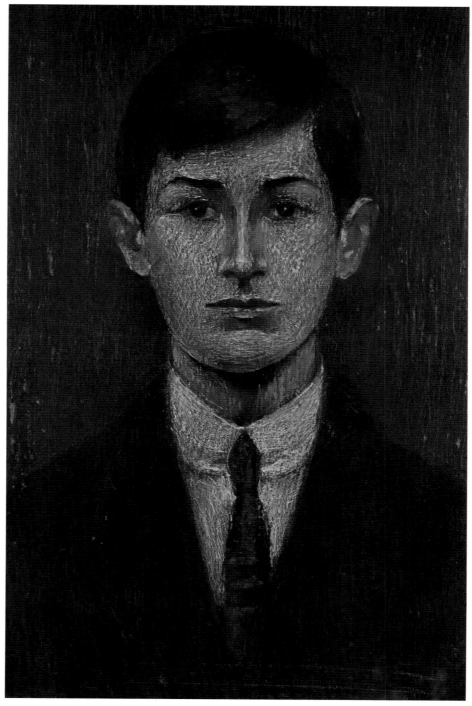

Portrait of a Boy, *c.* 1913–14
Oil on board, 37.3 x 26.4 (14¾ x 10½ in) • The Lowry, Salford

The dark background and jacket are lightened by the boy's shirt and skin tones. The boy (who may well be the same one seen in *Boy in a School Cap, see* page 99) looks directly out at the viewer with a serious, even sad, expression.

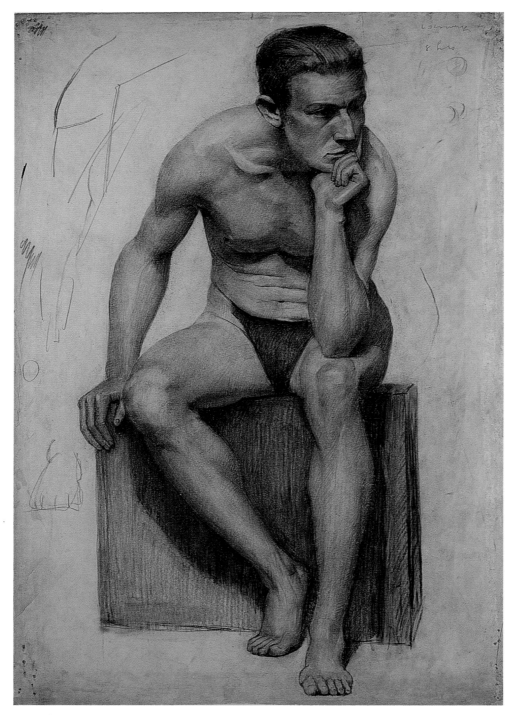

Seated Male Nude, *c.* 1914
Pencil on paper, 54.8 x 34.9 cm (21½ x 13¾ in) • The Lowry, Salford

Another finely worked drawing with a multitude of tonal varieties, shadowing and highlights. It is likely that the 'stump' has been used to blur edges and a rubber to create highlights.

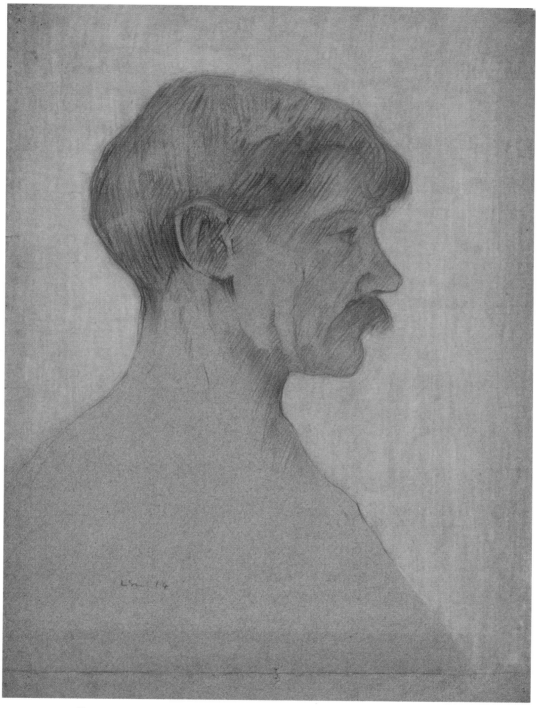

Head of a Man, 1914
Pencil and charcoal on paper, 45 x 32.3 cm (17¾ x 12¾ in)
• The Lowry, Salford

A profile work but one that nonetheless conveys a strong sense of the sitter's character and bearing. His luxuriant moustache is captured with multiple layers of pencil strokes.

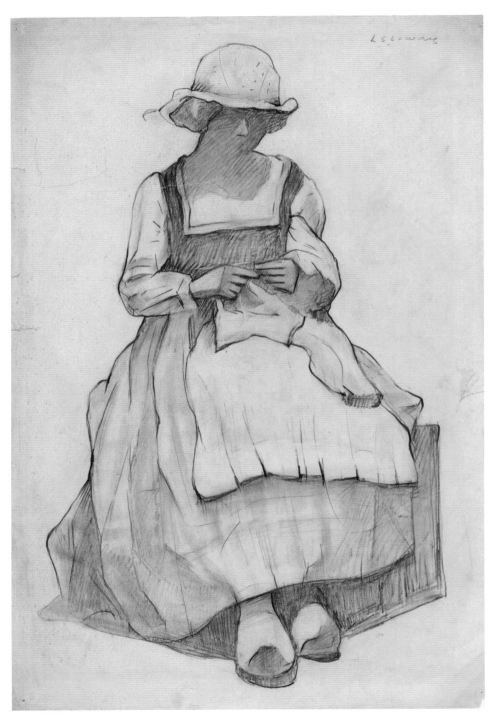

Study of Girl in Peasant Dress, *c.* **1917** A photograph in the archives shows Lowry in a costume class at the Salford School of Art.
Pencil on paper, 51 x 33.8 cm (20 x 13¼ in) • The Lowry, Salford Here the model is dressed as a Dutch peasant girl.

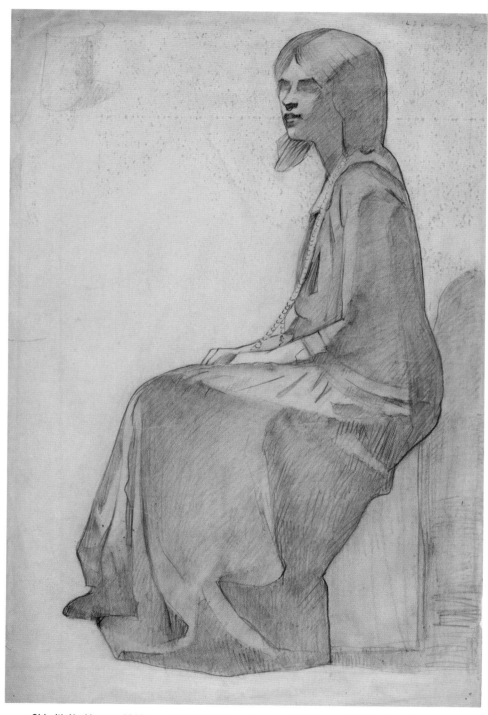

Girl with Necklace, *c.* 1917
Pencil on paper, 52.8 x 34.5 cm (20¾ x 13½ in) • The Lowry, Salford

In this study, Lowry has concentrated on creating the effects of the flowing drapery of the girl's dress as it shadows the contours of her figure.

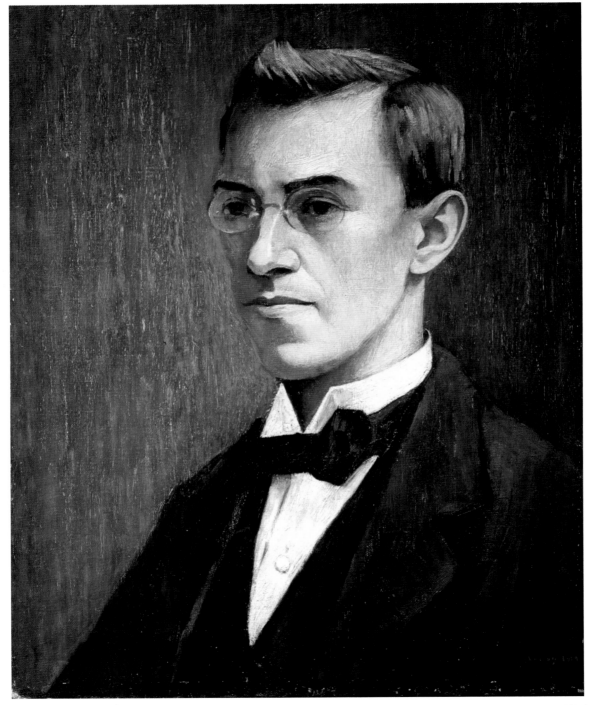

Frank Jopling Fletcher, 1919
Oil on canvas, 48.7 x 38.7 cm (19½ x 15¼ in) • The Lowry, Salford

Painted as a surprise gift for his friend, this work was intensely disliked by Fletcher and his family. Its reception was a significant factor in convincing Lowry that he was not a portrait painter.

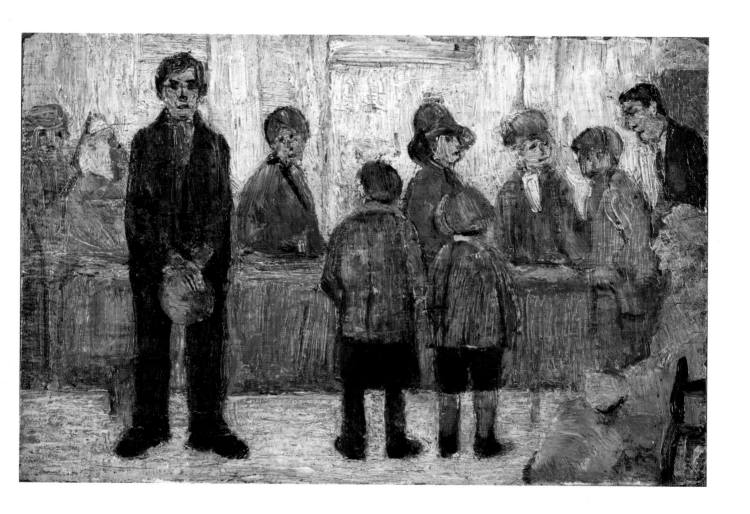

A Doctor's Waiting Room, *c.* **1920**
Oil on board, 27.3 x 40.9 cm (10¾ x 16 in) • The Lowry, Salford

A number of Lowry's works have a medical setting. The people here seem to be a collection of studies of individuals, almost forerunners to his later studies of 'grotesque' characters.

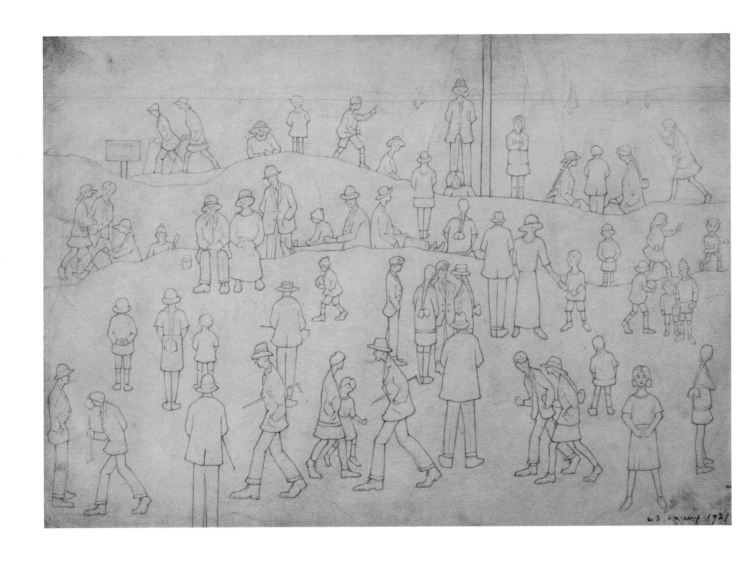

On the Sands, 1921
Pencil on paper, 27.3 x 36.7 (10¾ x 14½ in) • The Lowry, Salford

People at the seaside were to be a feature of Lowry's work throughout his life. This work is a study of a variety of characters and figures that were later to fill Lowry's many beach scenes.

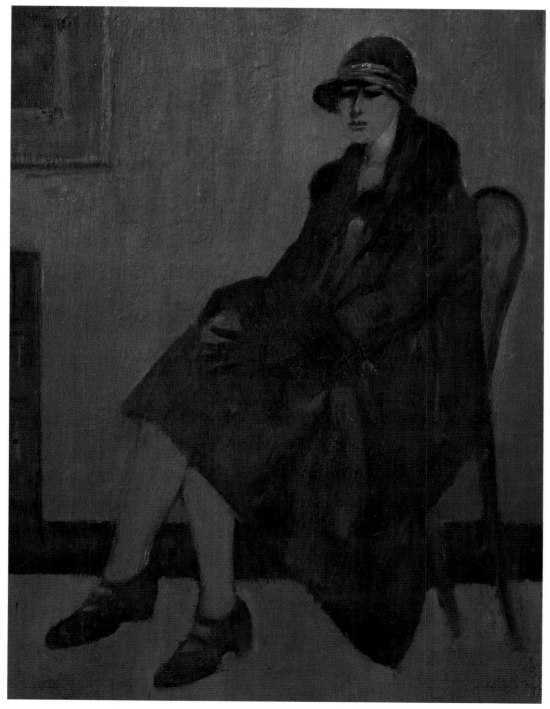

Woman in a Chair, 1921 and 1956
Oil on board, 41.8 x 34 cm (16½ x 13½ in) • The Lowry, Salford

This was a life painting made by Lowry in 1921. However, in 1956 he returned to the work, as he often did with his paintings, and repainted the background.

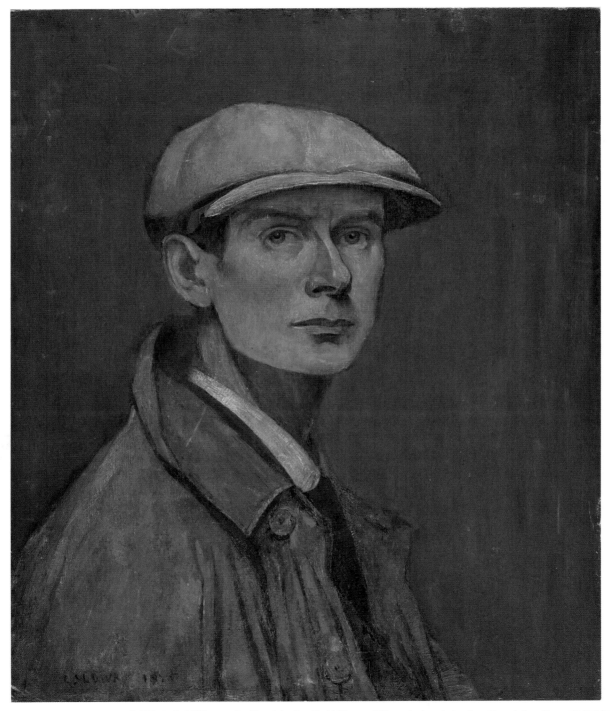

Self Portrait, 1925
Oil on board, 57.2 x 47.2 cm (22½ x 18½ in) • The Lowry, Salford

A self-contained and bold 37-year-old Lowry looks out at us from the painting. He recalls that he struggled over this work and when it was finished said: 'Never again, thank you.'

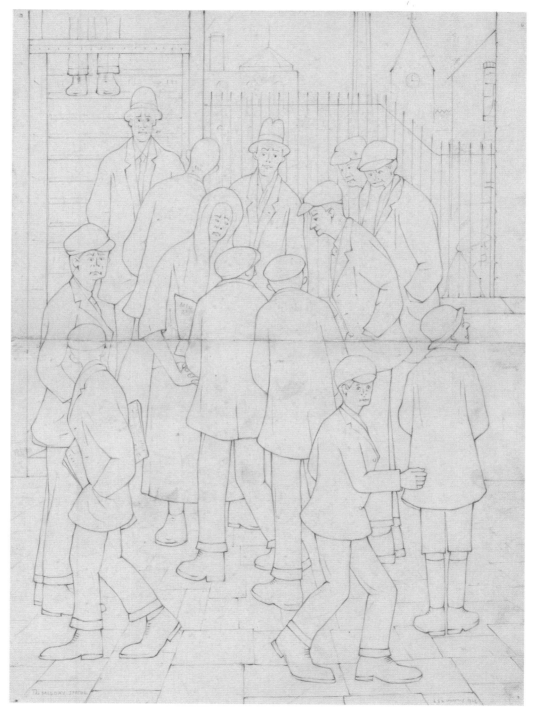

The Mid-Day Special, 1926
Pencil on paper, 38.4 x 27.8 cm (15 x 11 in) • The Lowry, Salford

Figures fill the paper, jostling with each other to find out the result of a race. Lowry drew an almost identical scene in 1922 called *The Result of the Race*.

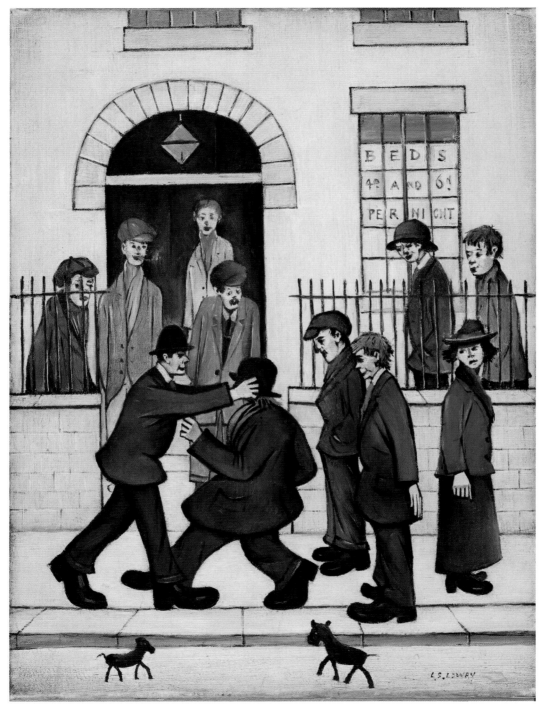

A Fight, *c.* 1935
Oil on canvas, 53.2 x 39.5 cm (21 x 15½ in) • The Lowry, Salford

Lowry said that he actually witnessed this scene in Manchester in front of a lodging house. He was fascinated by the way any signs of tension seemed to draw in a crowd. Two of Lowry's characteristic dogs also witness the scene.

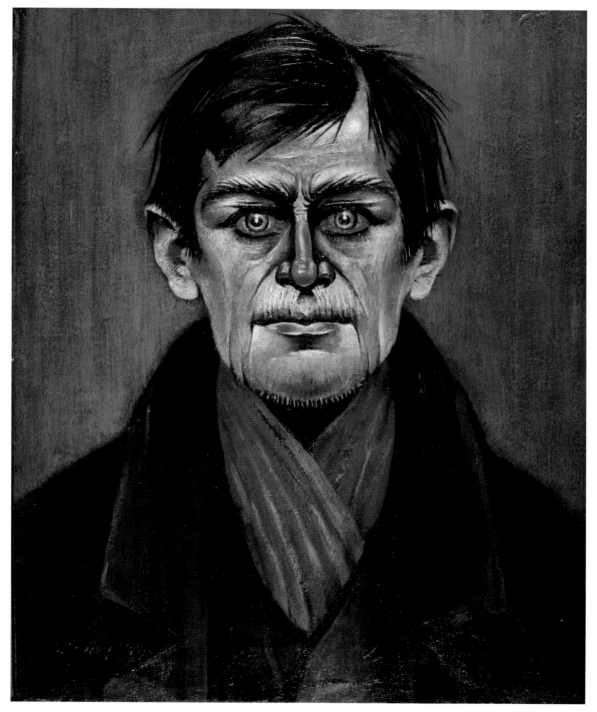

Head of a Man, 1938
Oil on canvas, 50.7 x 41 cm (20 x 16 in) • The Lowry, Salford

Lowry admitted that this was really an emotional self-portrait, which revealed his inner state during the final years of caring for his mother.

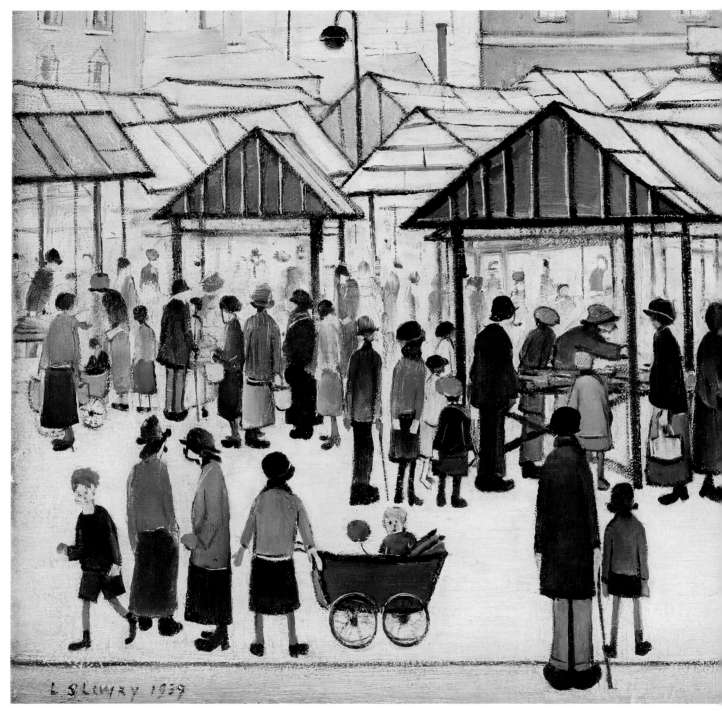

Market Scene, Northern Town (detail), 1939
Oil on canvas, 45.7 x 61.1 cm (18 x 24 in) • The Lowry, Salford

This scene is based on the market in Pendlebury. It is very light and bright with a lively throng of people and children enjoying the day. Note the tall man in a dark suit and hat in the foreground – could it be the artist himself?

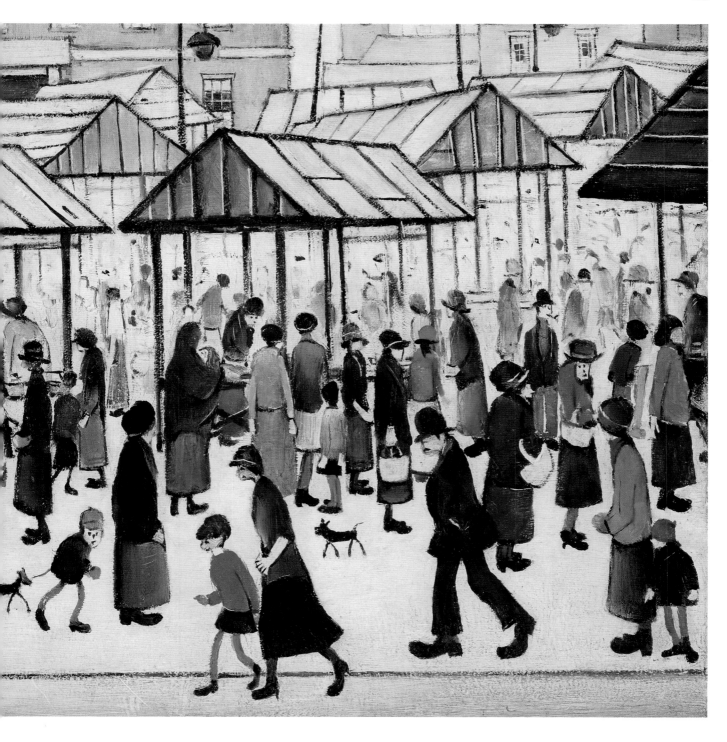

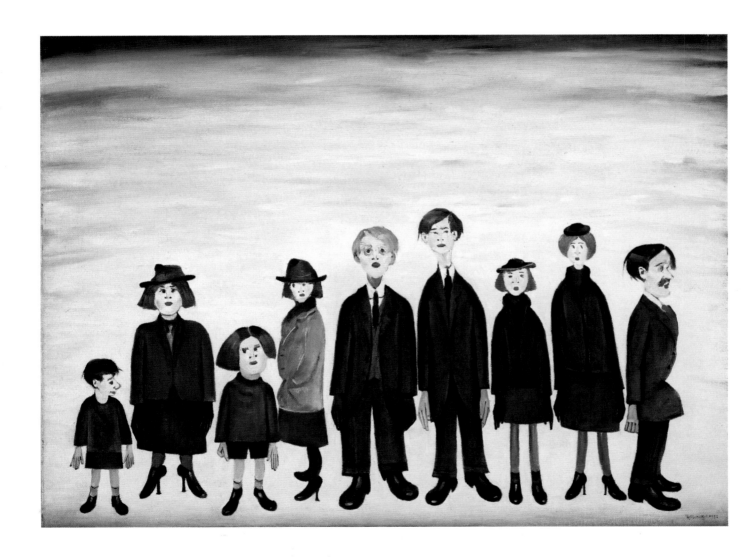

The Funeral Party, 1953
Oil on canvas, 76.1 x 102 cm (30 x 40 in) • The Lowry, Salford

Lowry explained that the man on the right is being ostracized because he has come to a funeral in a red tie. This work was described in a newspaper article as having 'all the love and compassion drained away'.

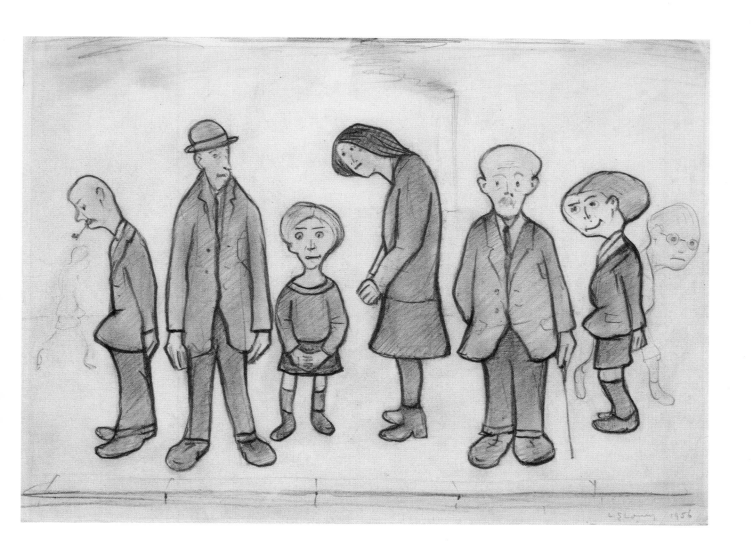

Family Group, 1956
Pencil on paper, 25.5 x 35.5 cm (10 x 14 in) • The Lowry, Salford

A work of caustic humour cruelly making fun of a family group whose members appear to have little in common. A mill tower belching smoke lurks in the background.

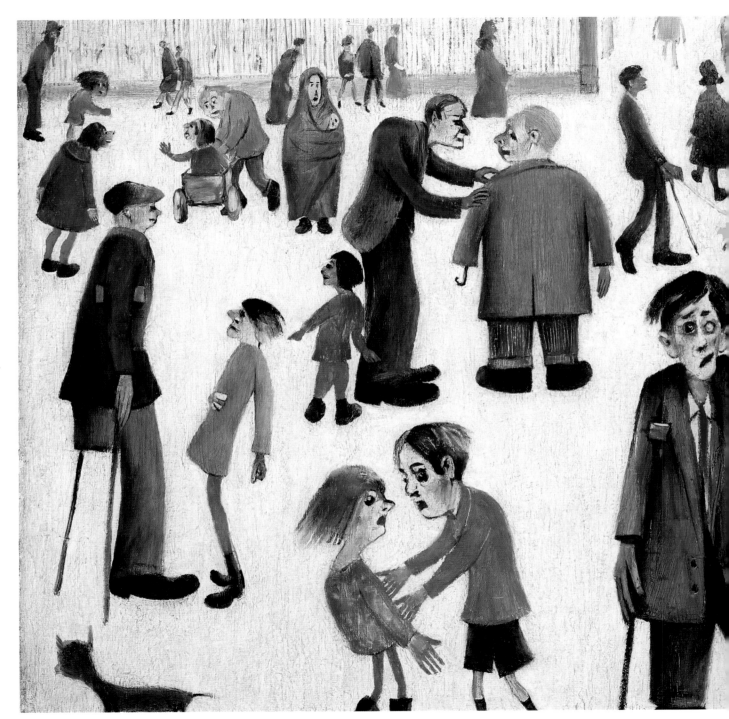

The Cripples (detail), 1949
Oil on canvas, 76 x 101.5 cm (30 x 40 in) • The Lowry, Salford

Lowry said he had recorded all these people in and around Manchester. He acknowledged them as 'real people, sad people' but he painted them in a direct way without sentimentality.

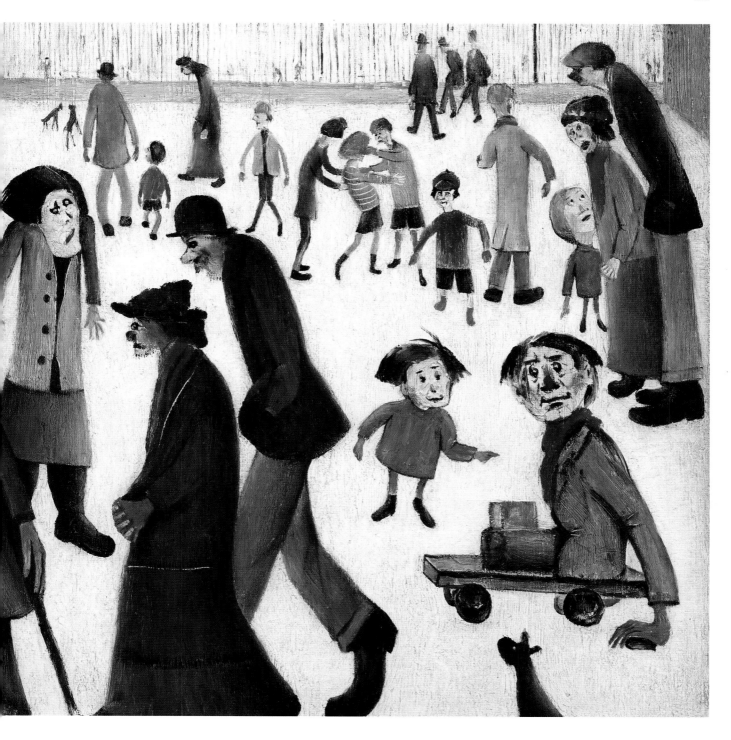

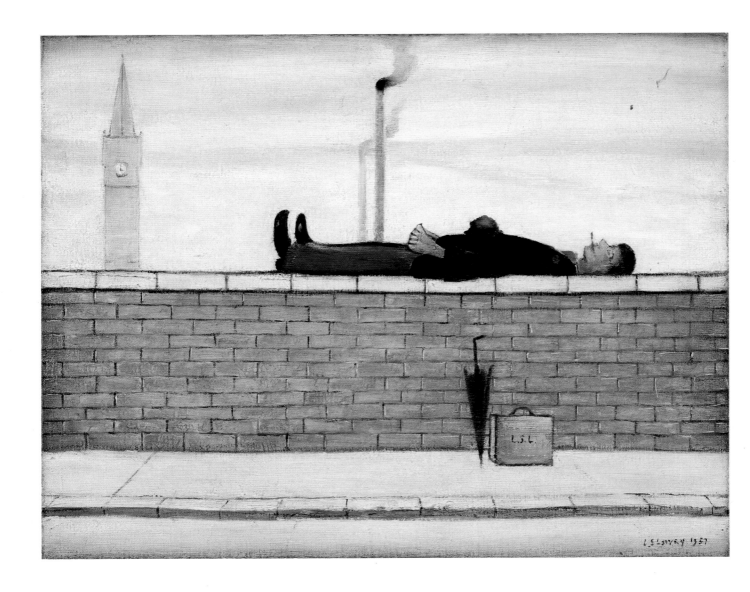

Man Lying on a Wall, 1957
Oil on canvas, 40.7 x 50.9 cm (16 x 20 in) • The Lowry, Salford

Lowry said that he actually saw this well-dressed man lying on a wall. This incident clearly aroused Lowry's humour and approval, for he put his own initials on the man's briefcase.

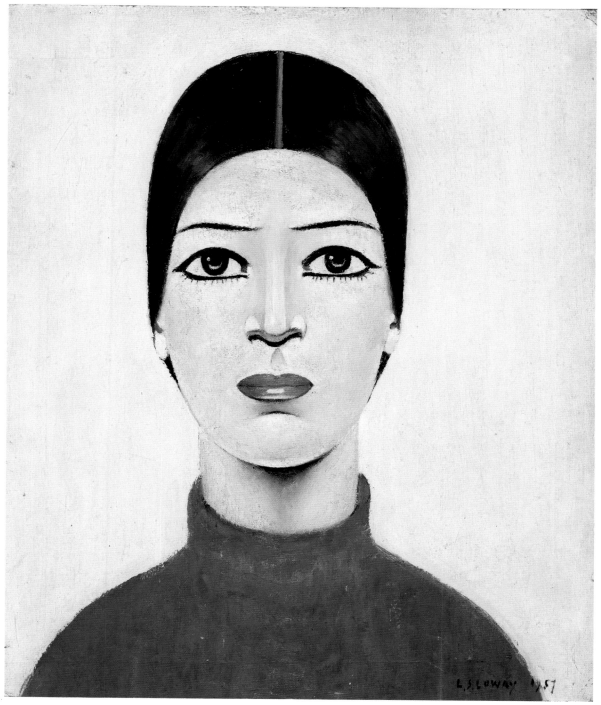

Portrait of Ann, 1957
Oil on board, 35.5 x 30.5 cm (14 x 12 in) • The Lowry, Salford

A portrait of the mysterious Ann whom Lowry would often talk of but whom no one seems to have met.
Perhaps she was a composite of a number of different women he had known in his life?

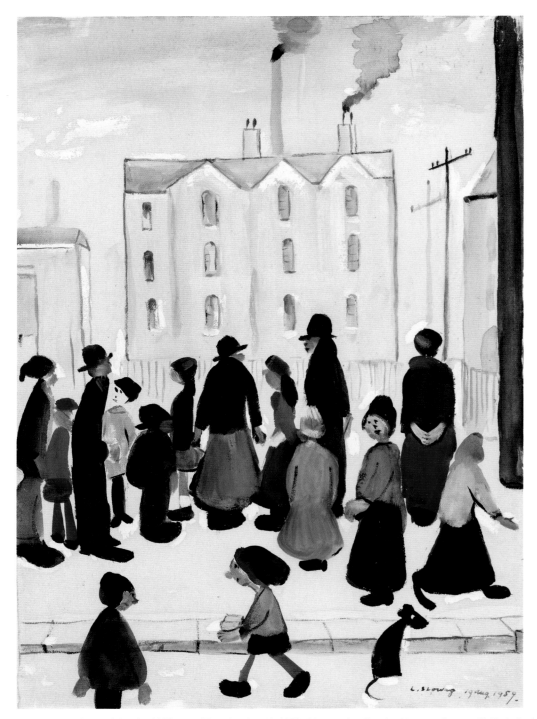

Group of People, 1959
Watercolour on paper, 35.6 x 25.5 cm (14 x 10 in)
• The Lowry, Salford

Although painted in 1959, this scene is a throwback to an earlier age with the ladies in long skirts and the mill towers of his earlier industrial scenes in the background. This is one of Lowry's rare uses of watercolour in illustrating an industrial setting.

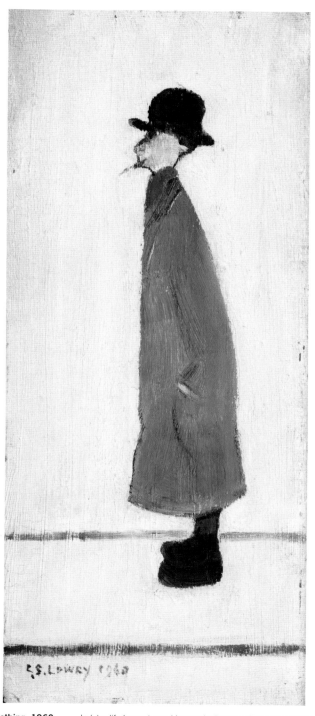

Gentleman Looking at Something, 1960
Oil on board, 24.5 x 10 cm (9¾ x 4 in) • The Lowry, Salford

In later life Lowry turned increasingly to small pictures of individual figures. These would often be humorous images – sometimes almost caricatures – which critics at times considered cruel and demeaning.

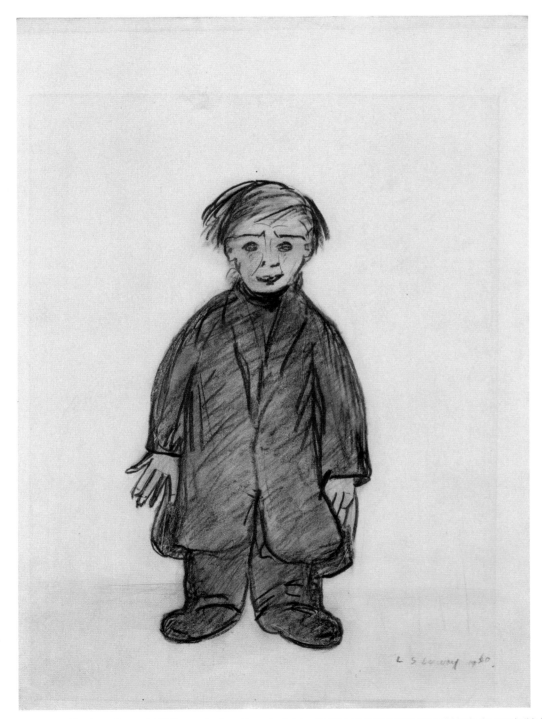

Man in an Overcoat, 1960
Pencil on paper, 30.6 x 22.6 cm (12 x 8 in) • The Lowry, Salford

Another of Lowry's often caustic close-up studies of derelict individuals; the man in this image wears clothes that are too big for him: Lowry himself said, 'There's a grotesque streak in me and I can't help it.'

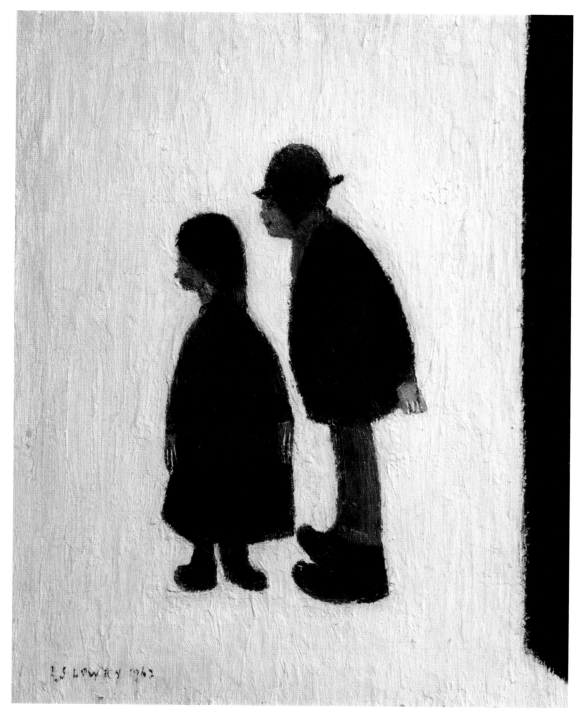

Two People, 1962
Oil on board, 29.5 x 24.5 cm (11½ x 9¾ in) • The Lowry, Salford

Another example of figures against an almost blank background, which intensifies our scrutiny of them. Who are these people? What are they looking at so intently? We will never know.

Indexes

Index of Works

Page numbers in *italics* refer to illustration captions.

General Index

Masterpieces of Art

FLAME TREE PUBLISHING

A new series of carefully curated print and digital books covering the world's greatest art, artists and art movements.

If you enjoyed this book, please sign up for updates, information and offers on further titles in this series at

blog.flametreepublishing.com/art-of-fine-gifts/